Wonderful OWLS Adult Coloring Book

Enjoy hours of relaxing creativity with these happy, mischievous owls Coloring is a fun, artistic experience, and a creative way to unwind. Use each of the pages in Owls Coloring Book as a launching pad to spark your creativity and unleash your inner artist. Each adorable avian will take you to a happy place where you can play with doodles, shapes, and patterns. Happy art making!

Karin Offender

Copyright © 2019 by Karin Offender

All rights reserved. No part of this publication may be reproduced, stored in a retrieval system, or transmitted in any from or by any means, electronic, mechanical, photocopying, recording or otherwise, without the prior written permission of the publisher.

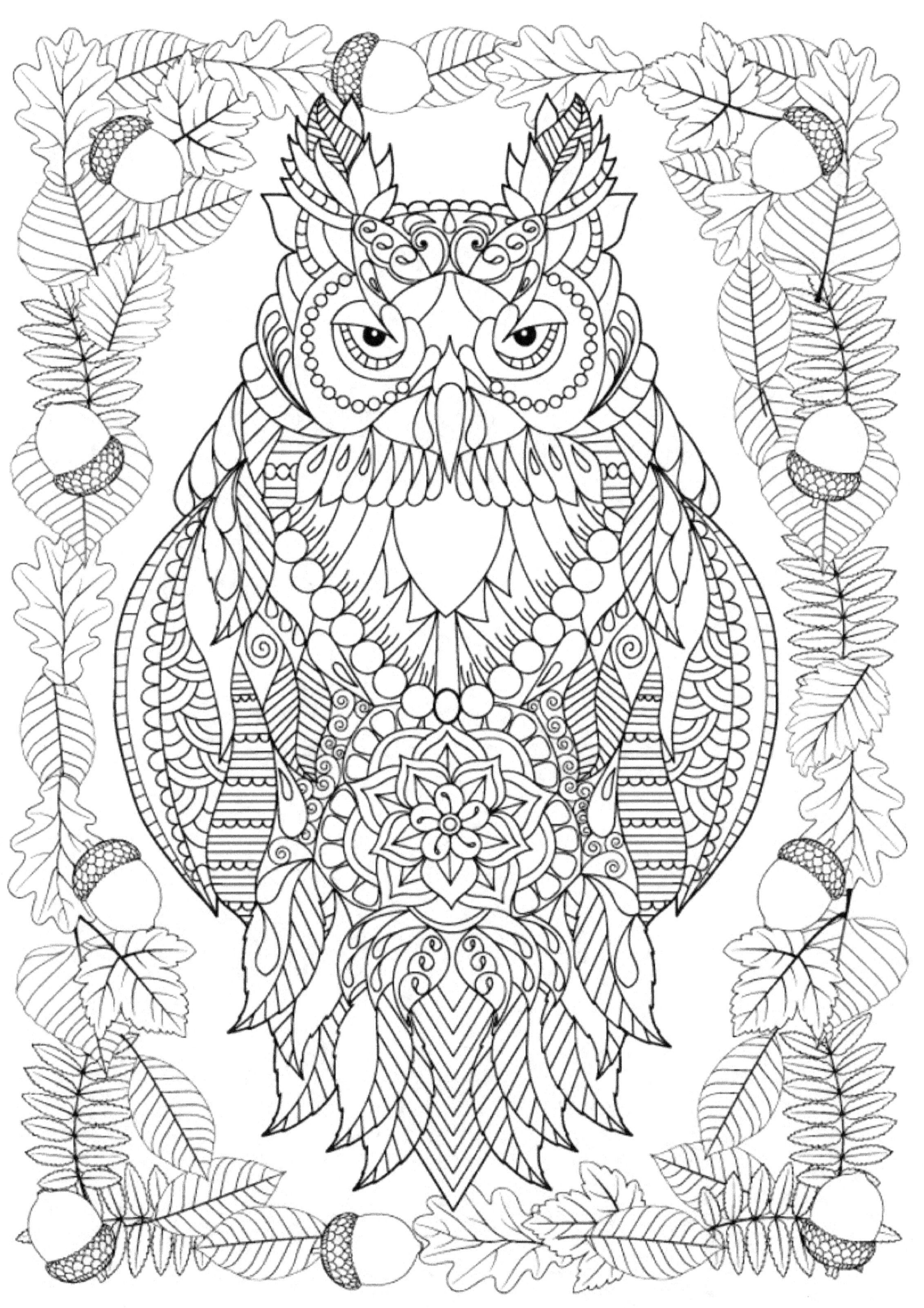

Coloring Test Page

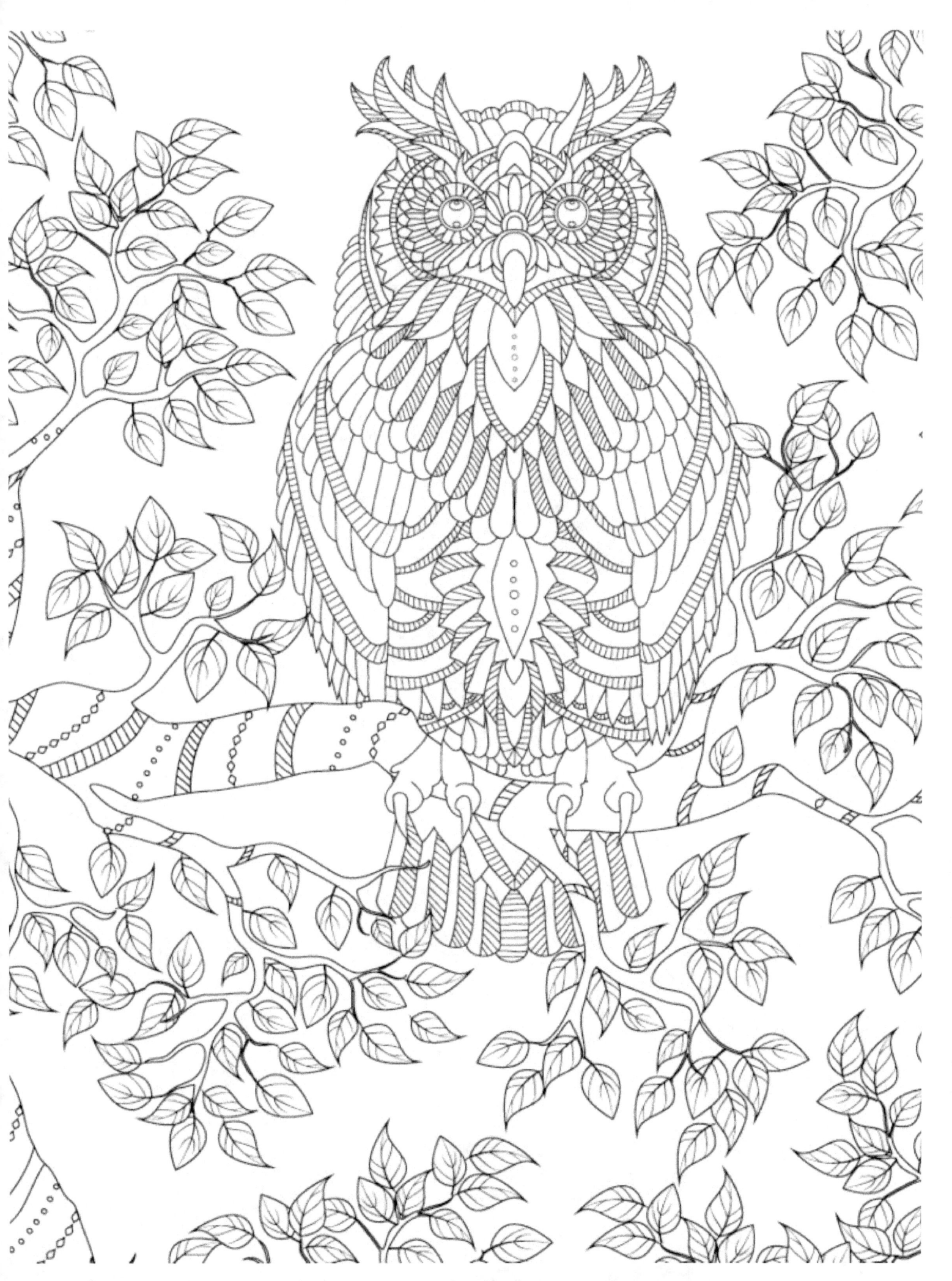

Coloring Test Page

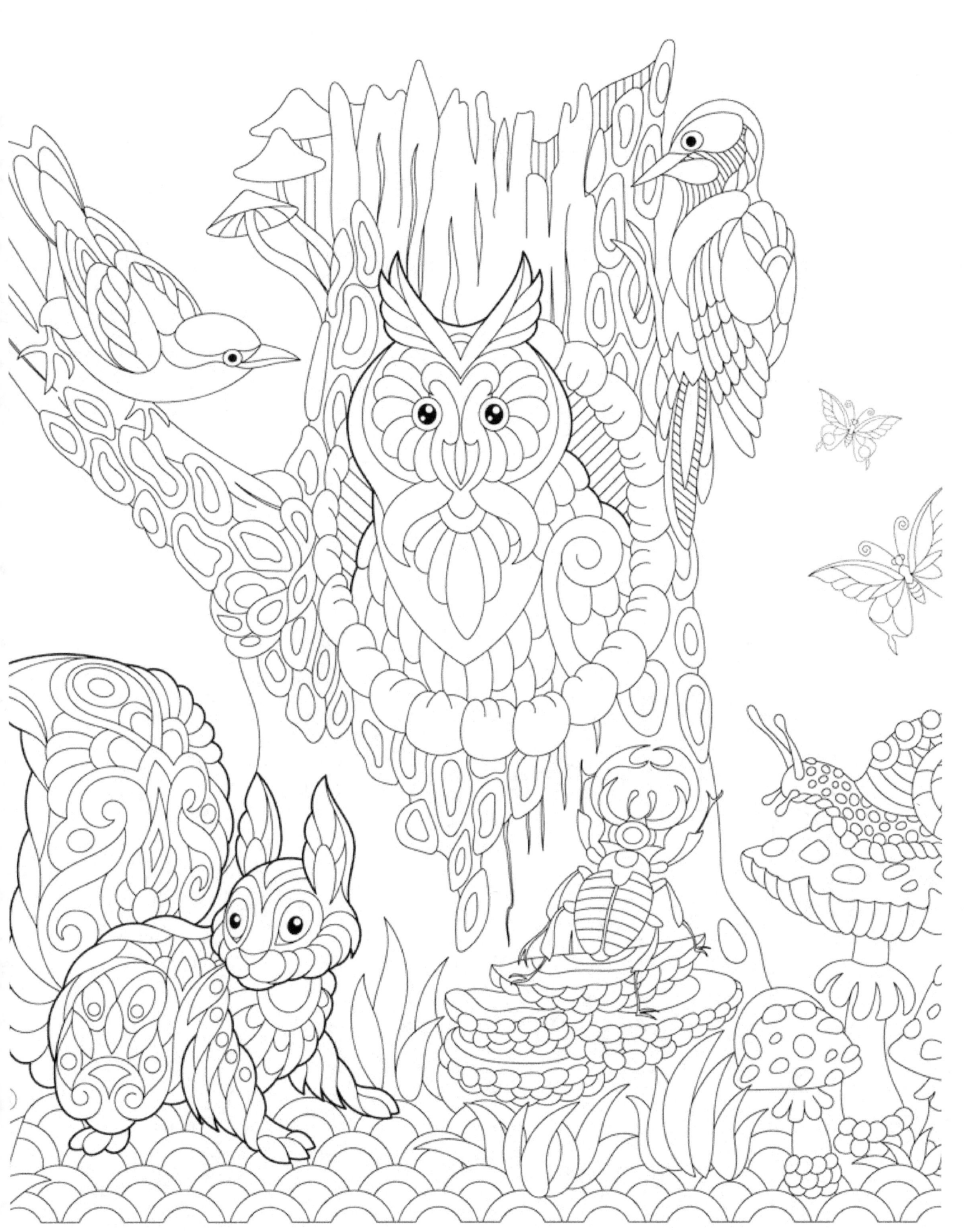

Coloring Test Page

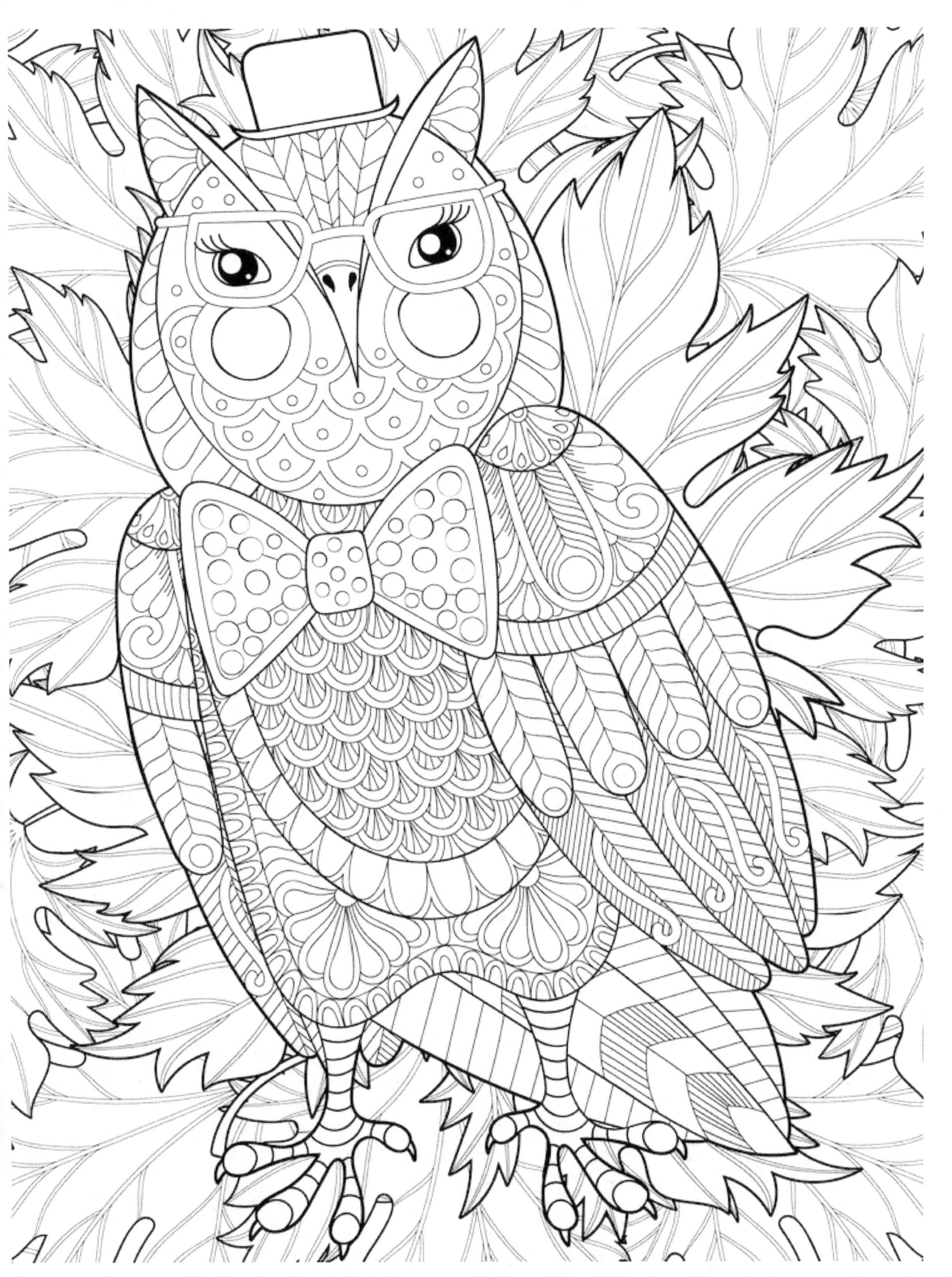

Coloring Test Page

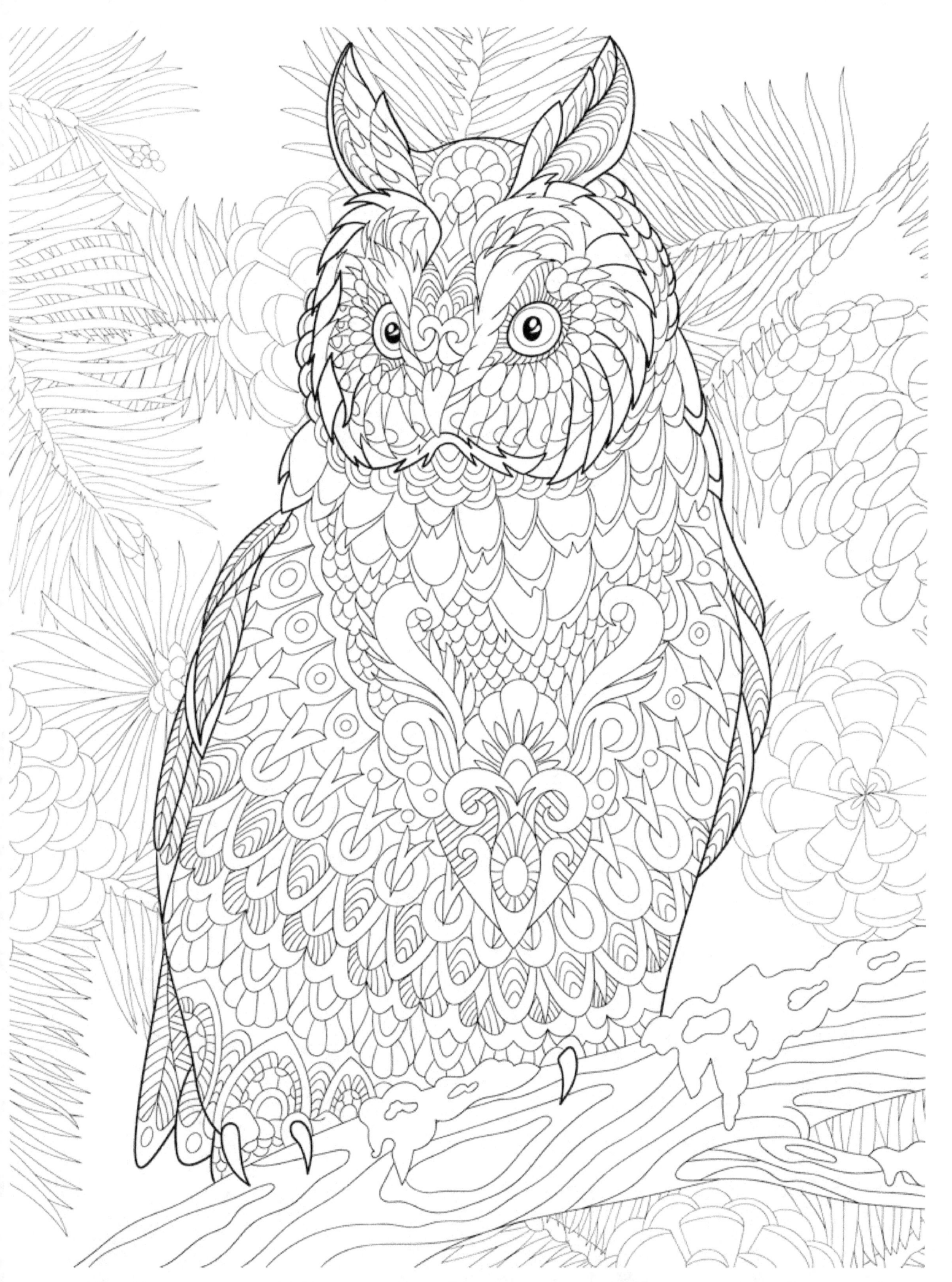

Coloring Test Page

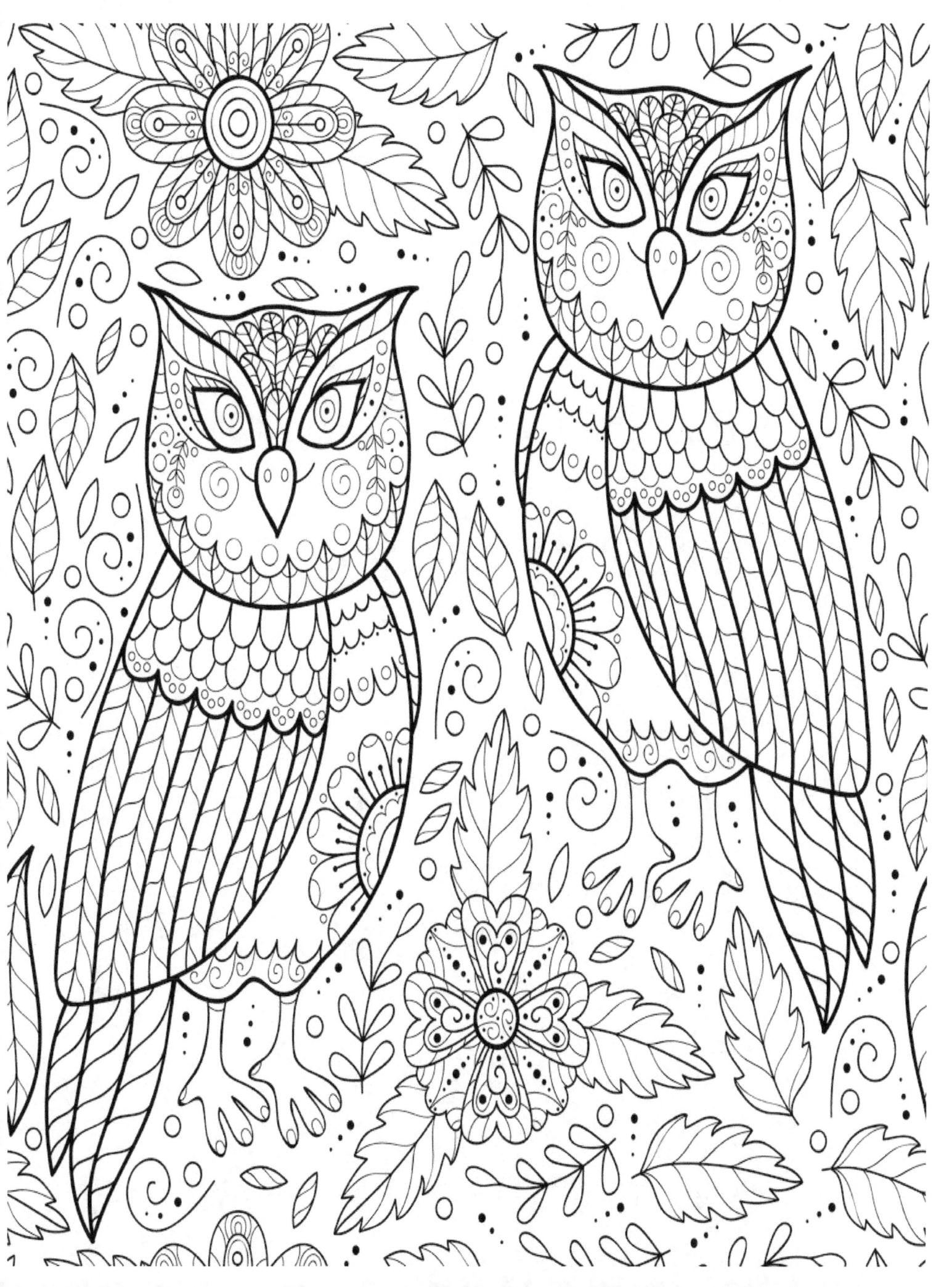

Coloring Test Page

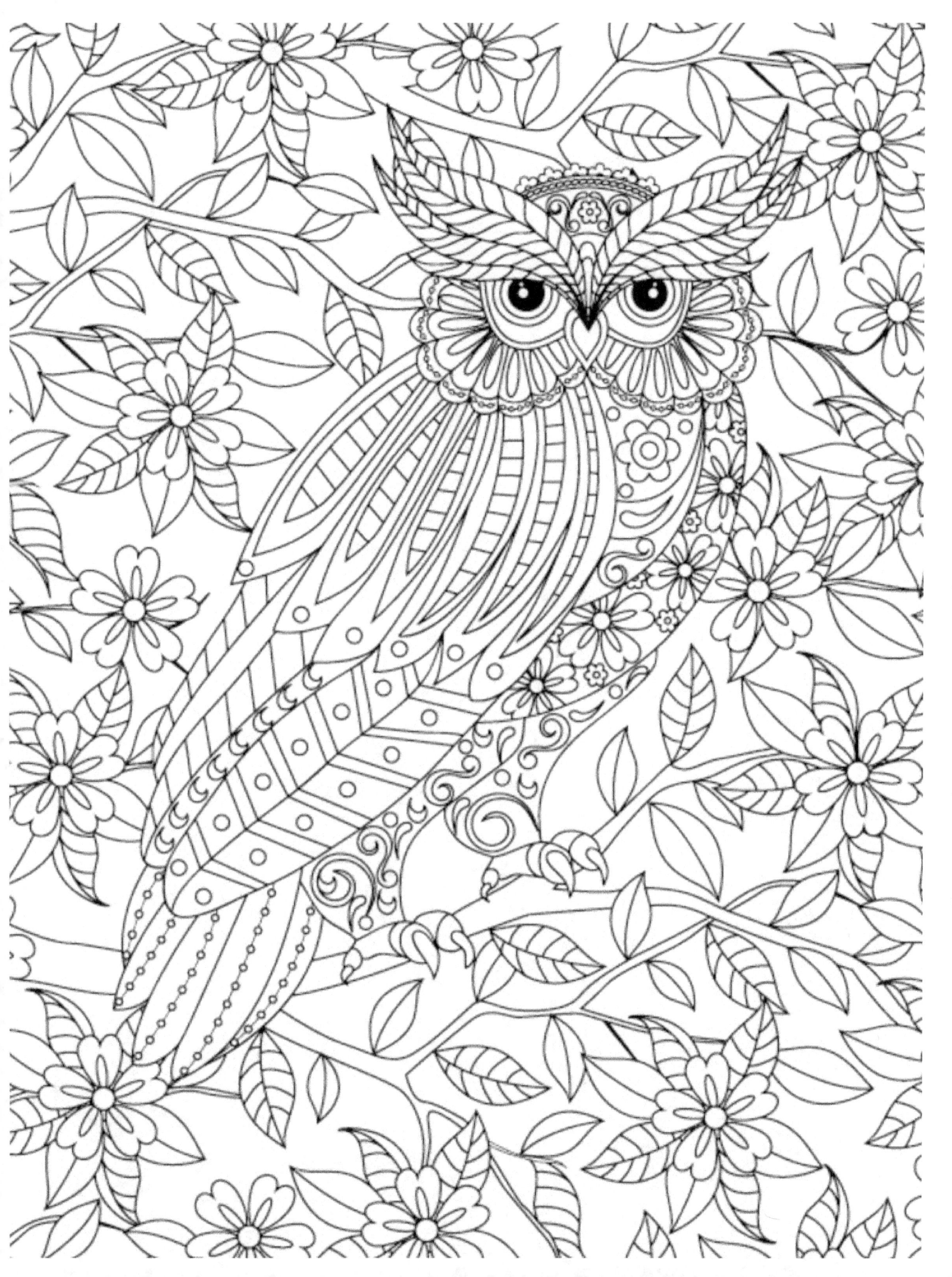

Coloring Test Page

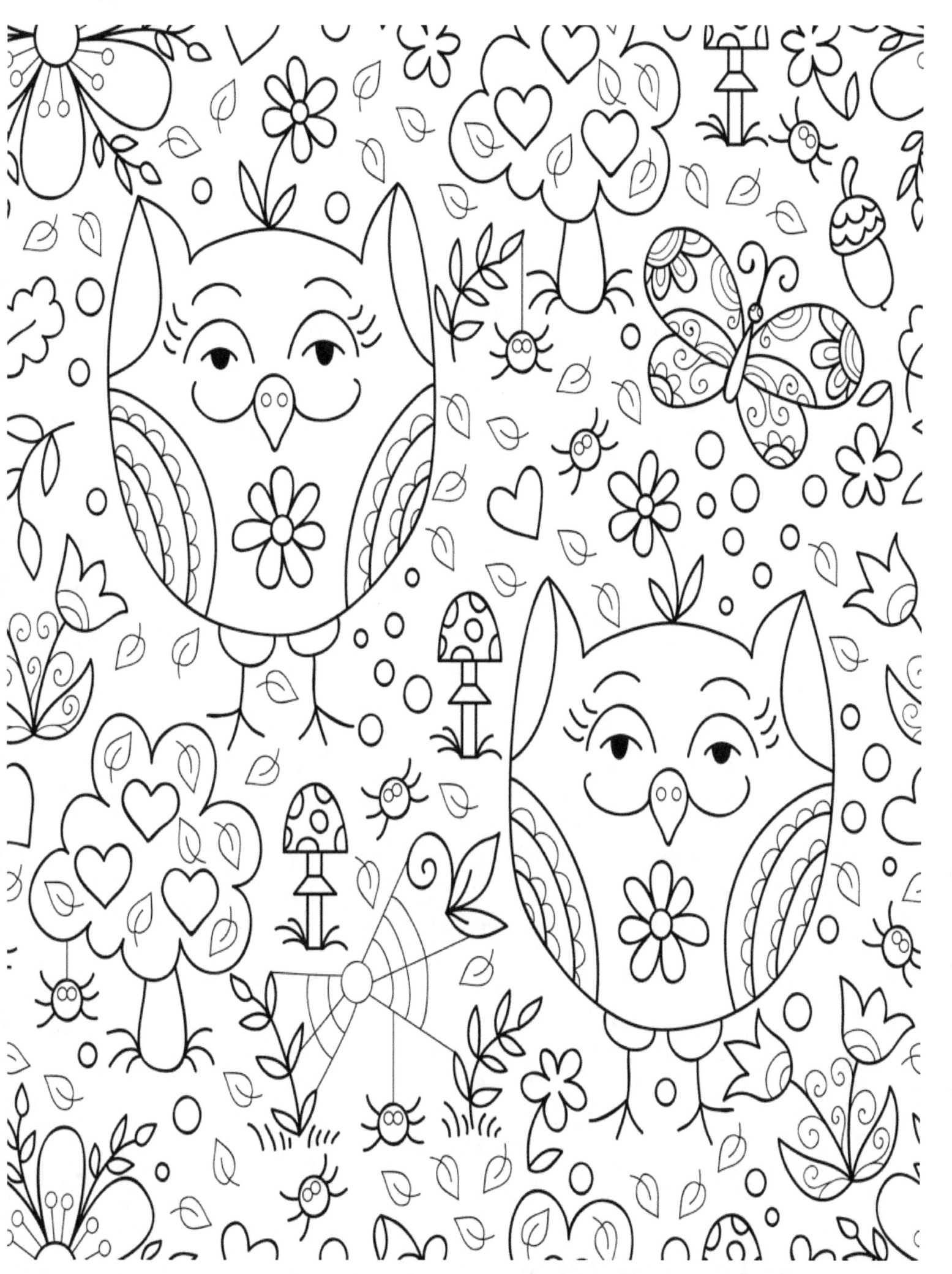

Coloring Test Page

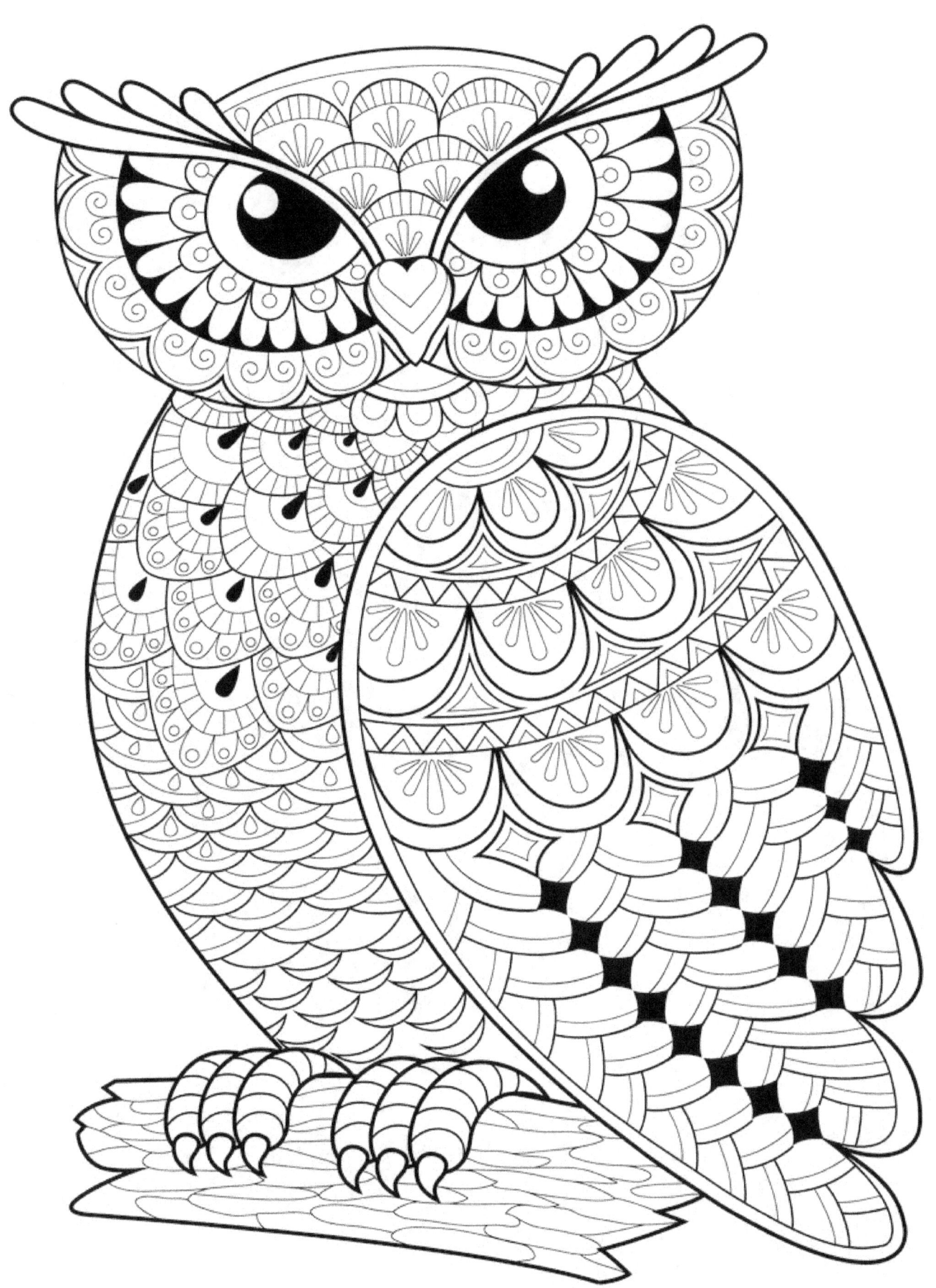

Coloring Test Page

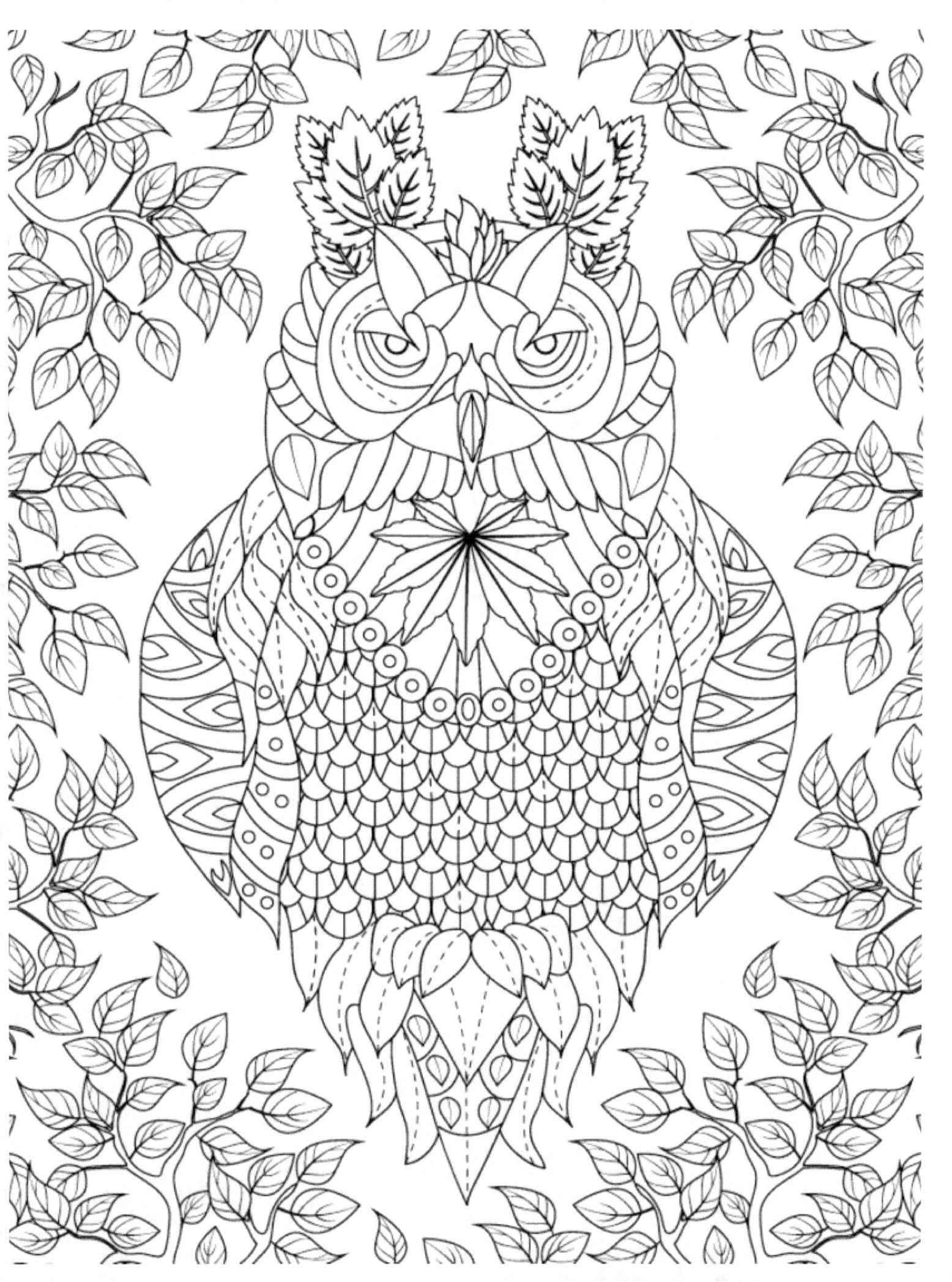

Coloring Test Page

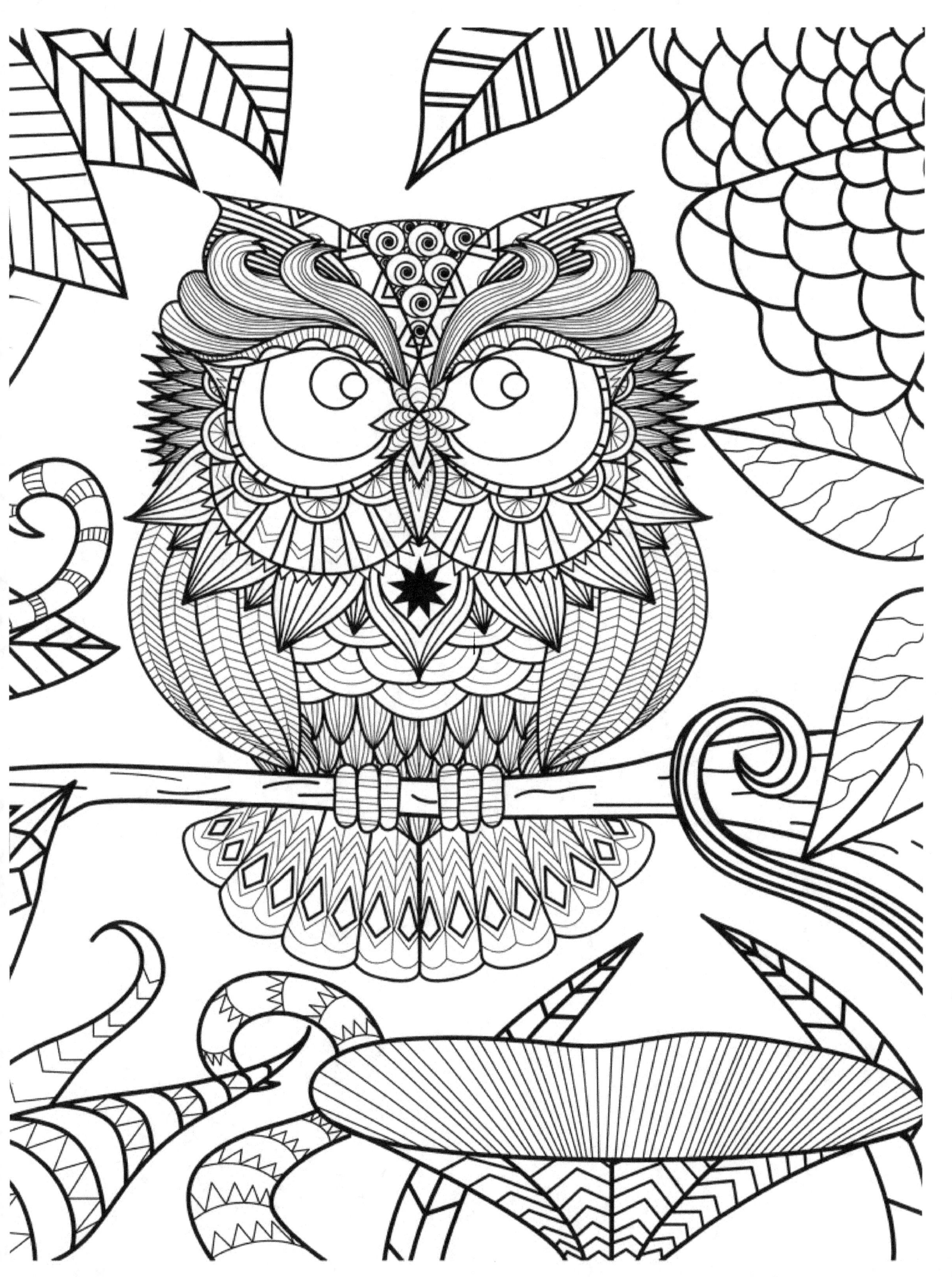

Coloring Test Page

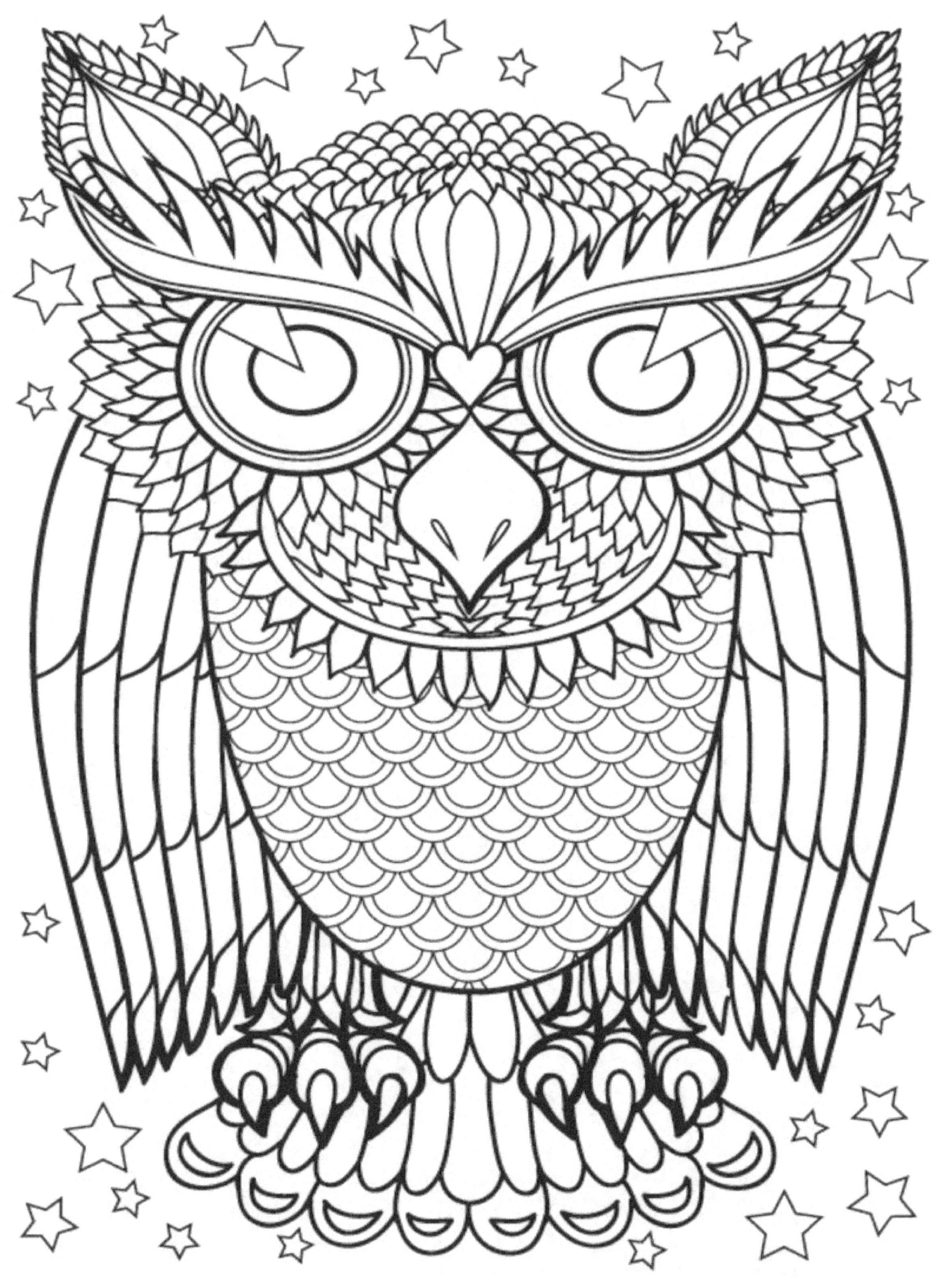

Coloring Test Page

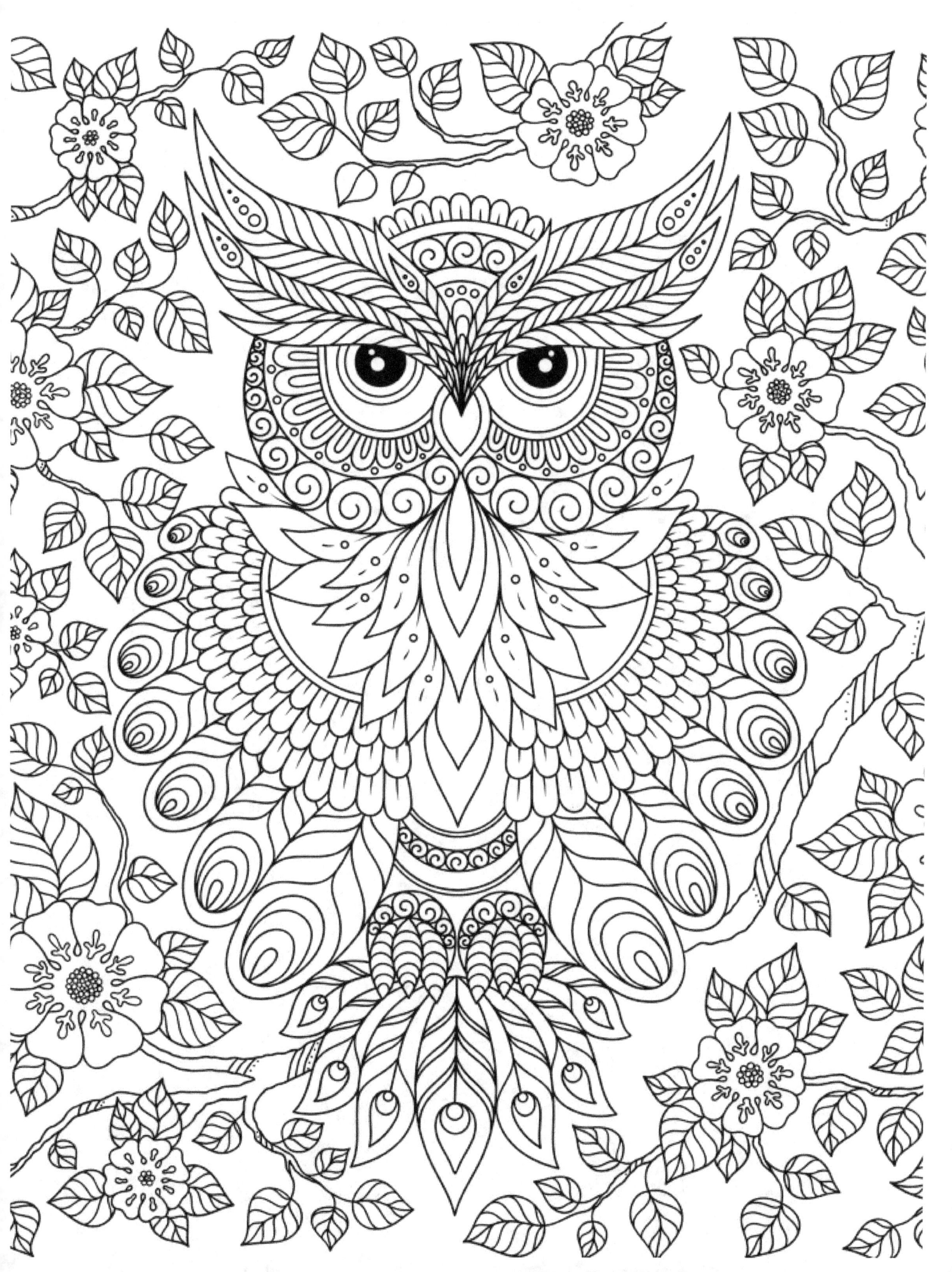

Coloring Test Page

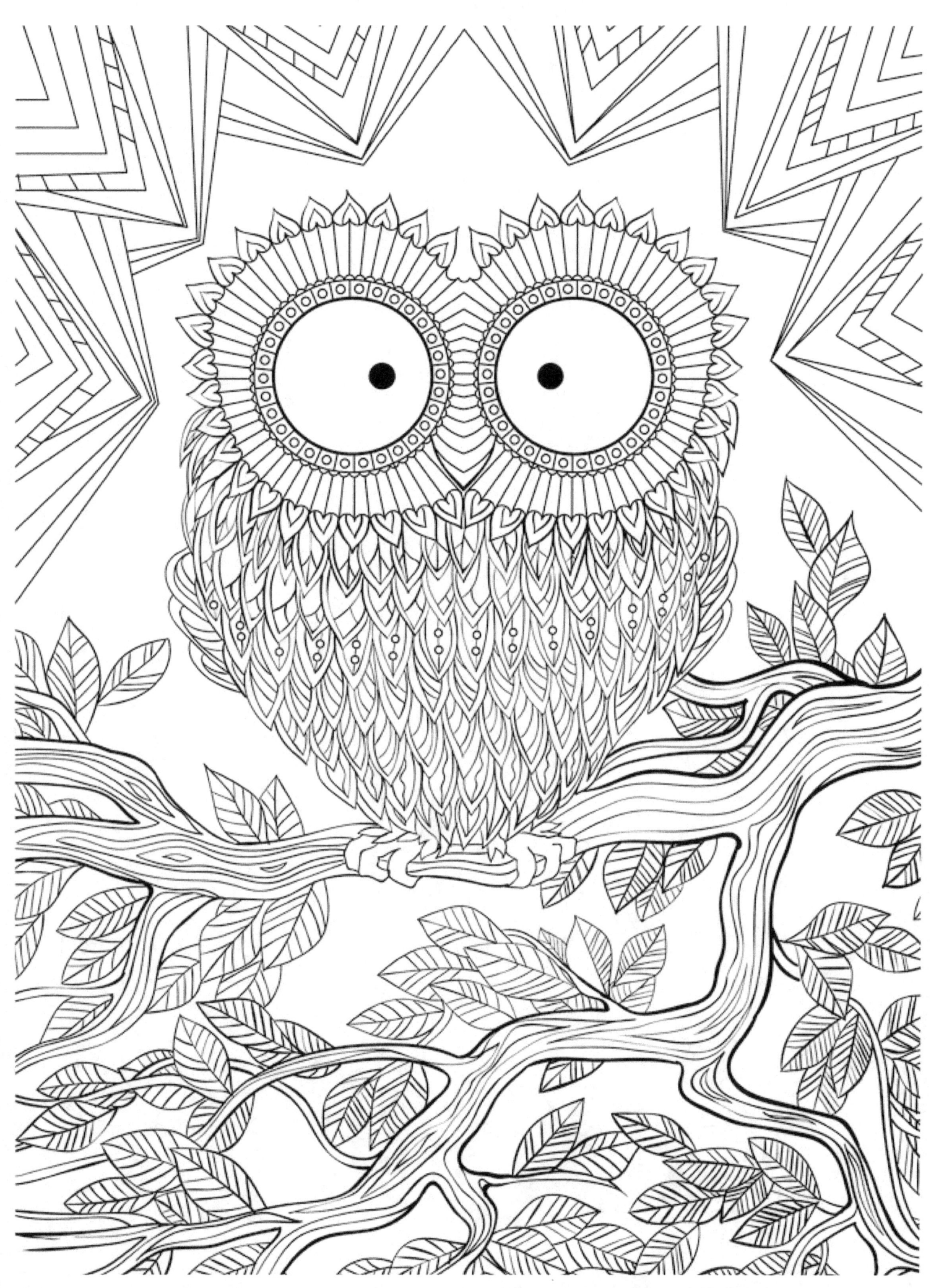

Coloring Test Page

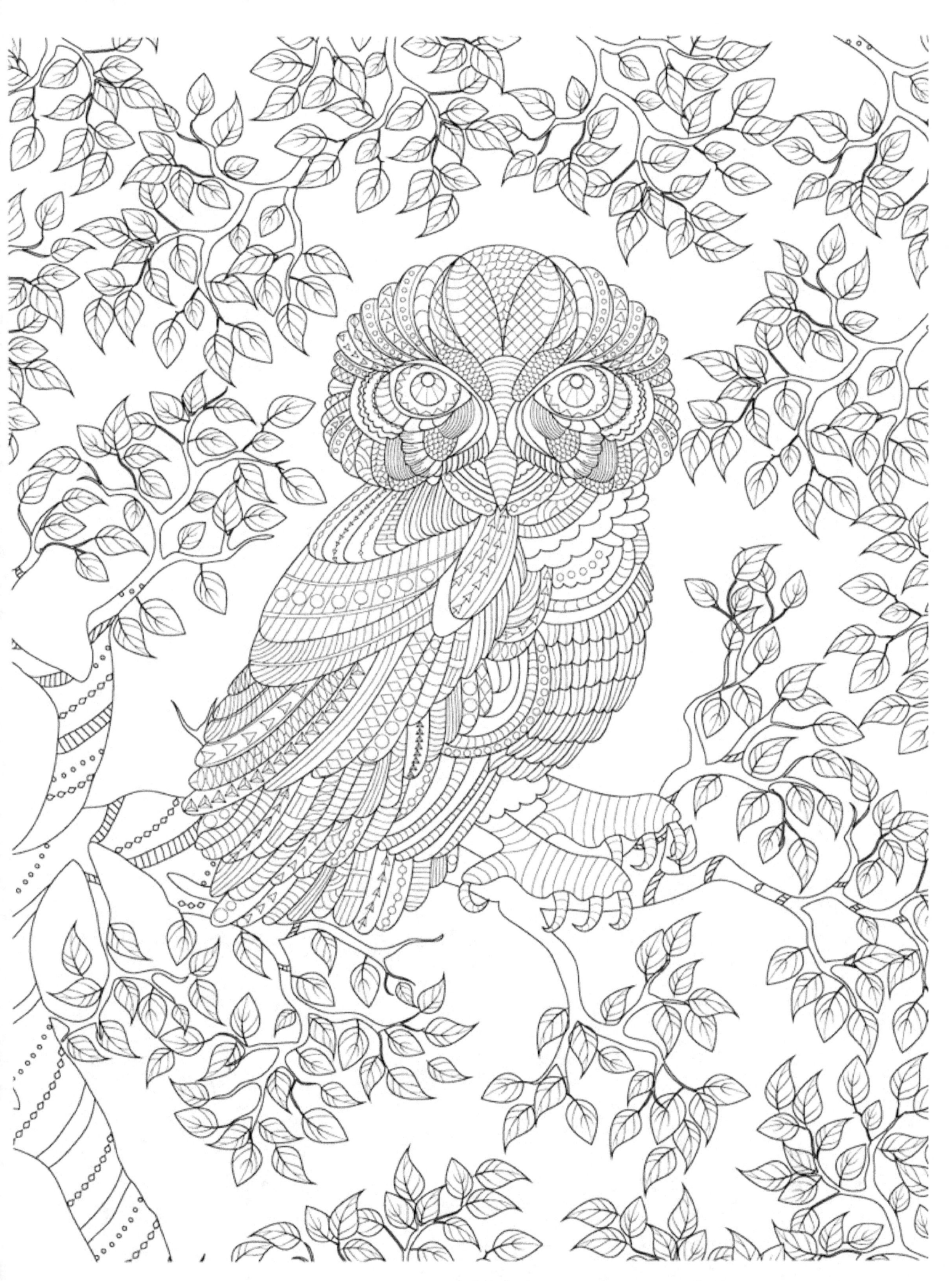

Coloring Test Page

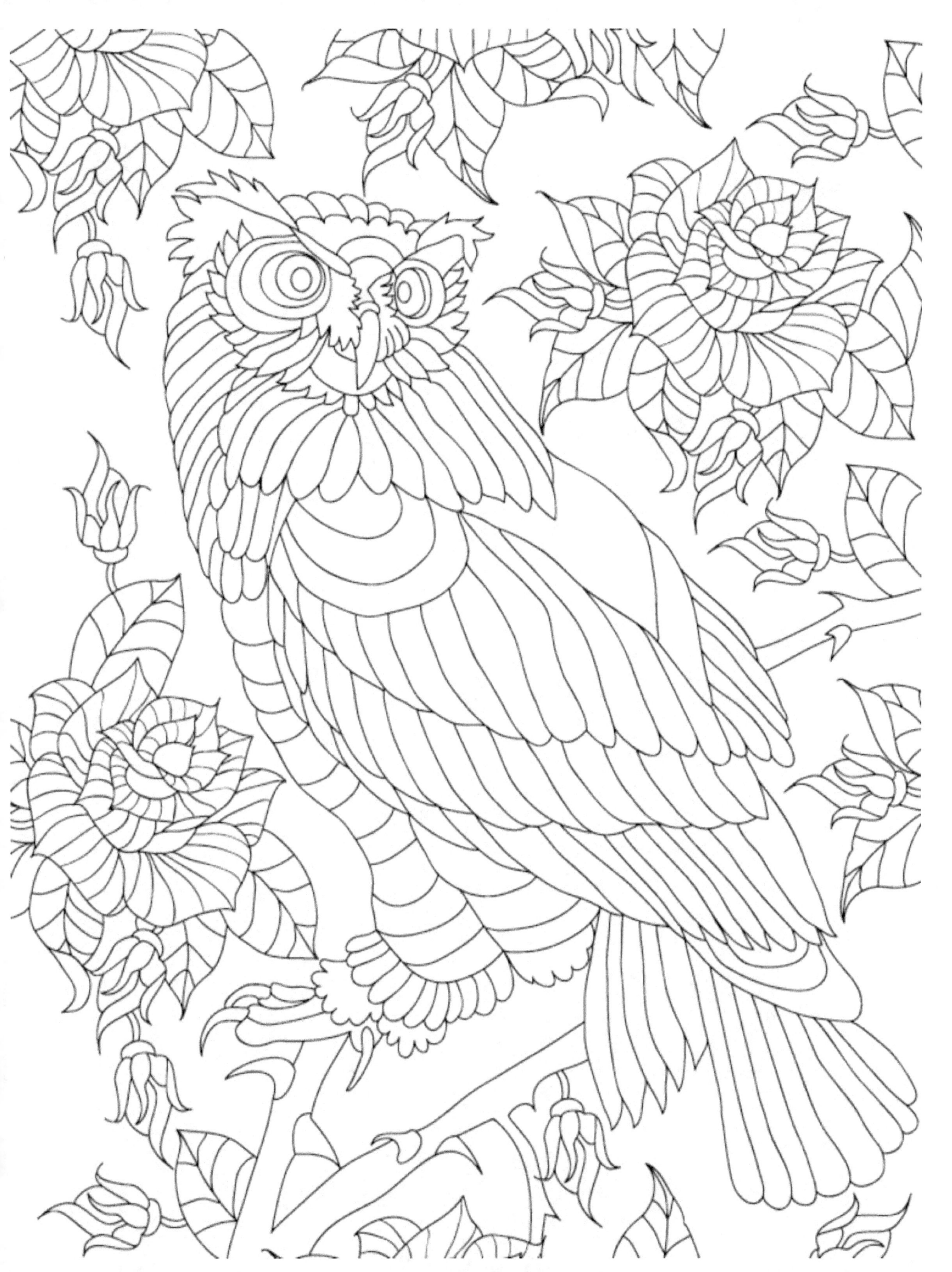

Coloring Test Page

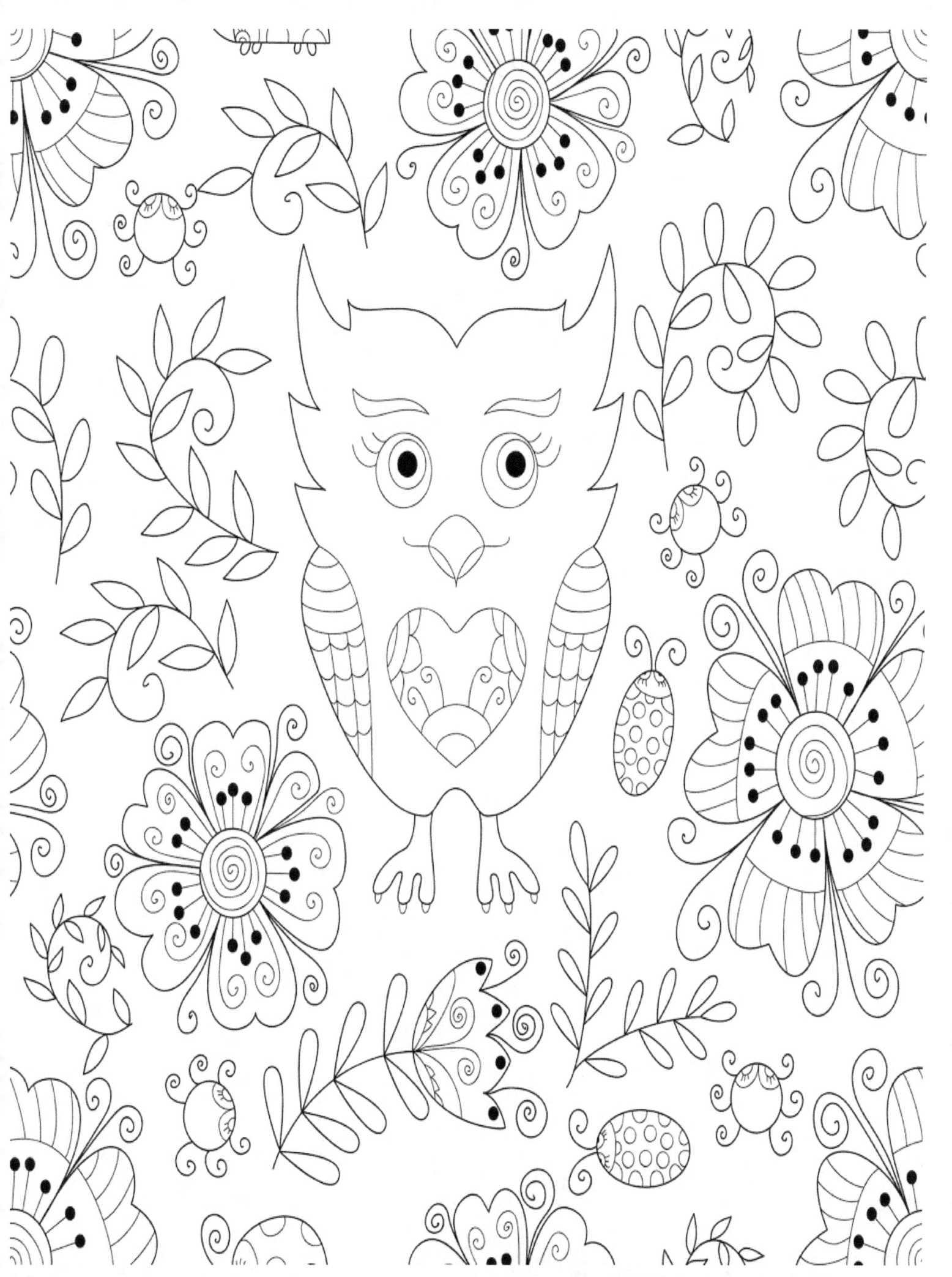

Coloring Test Page

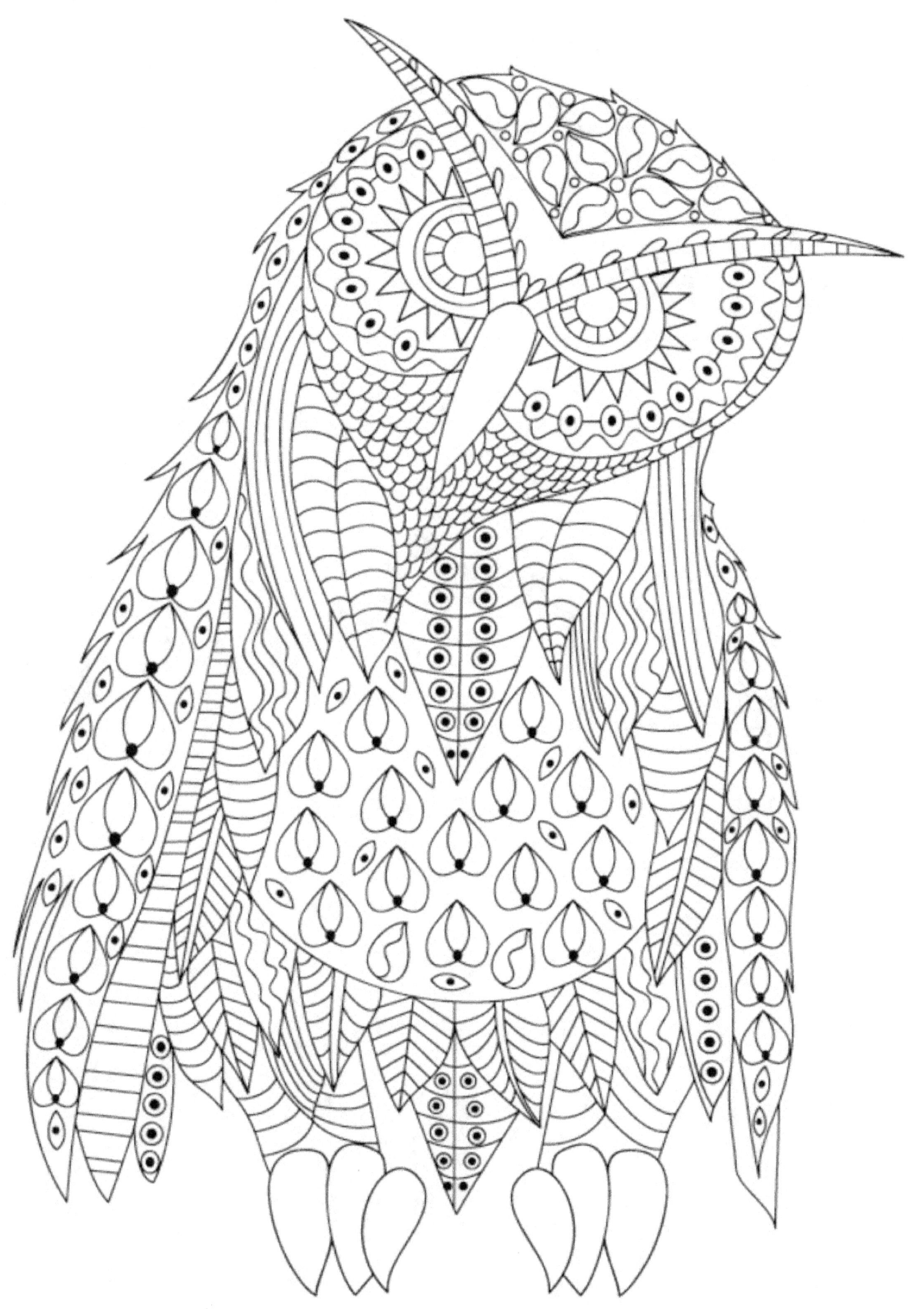

Coloring Test Page

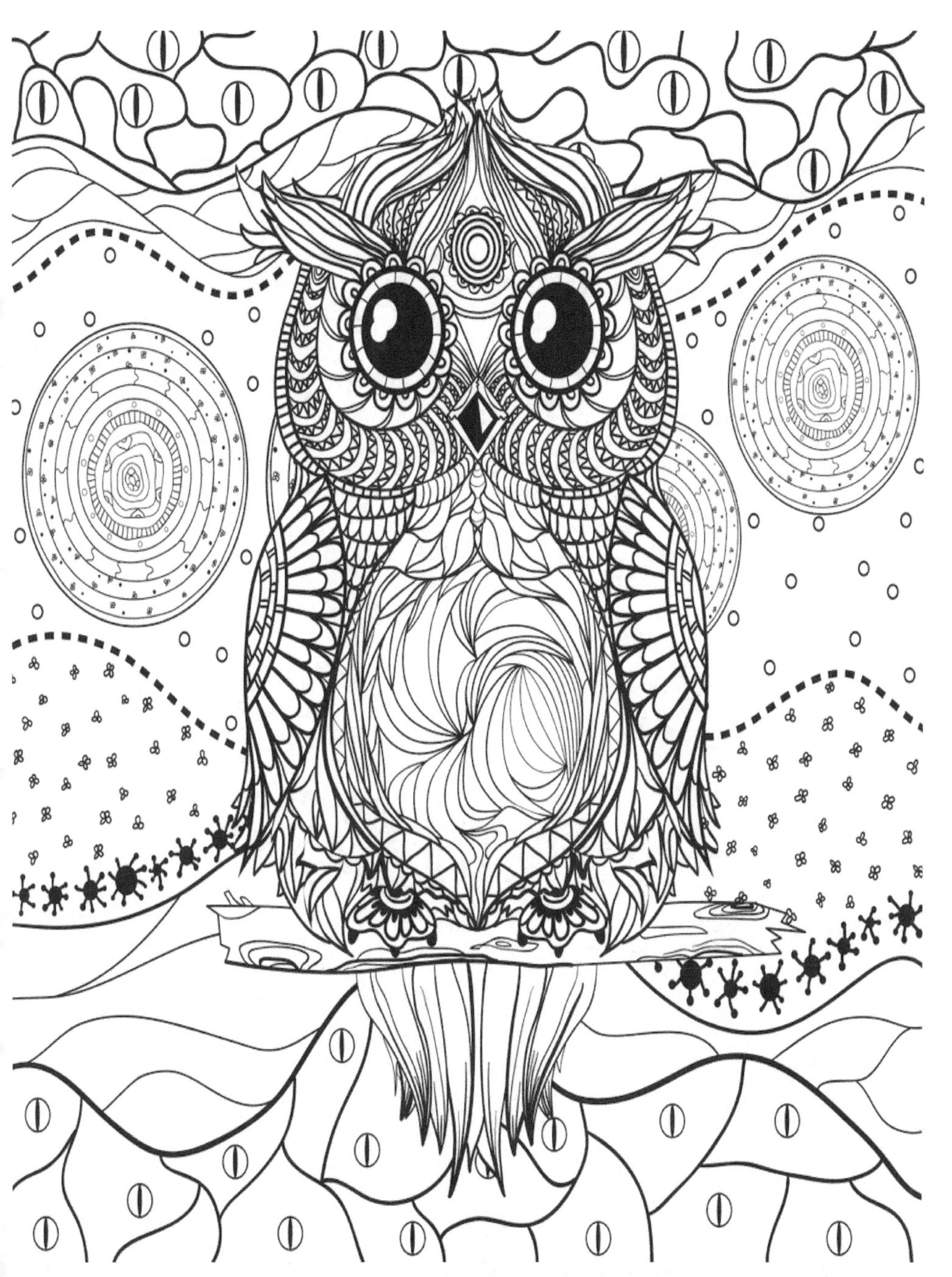

Coloring Test Page

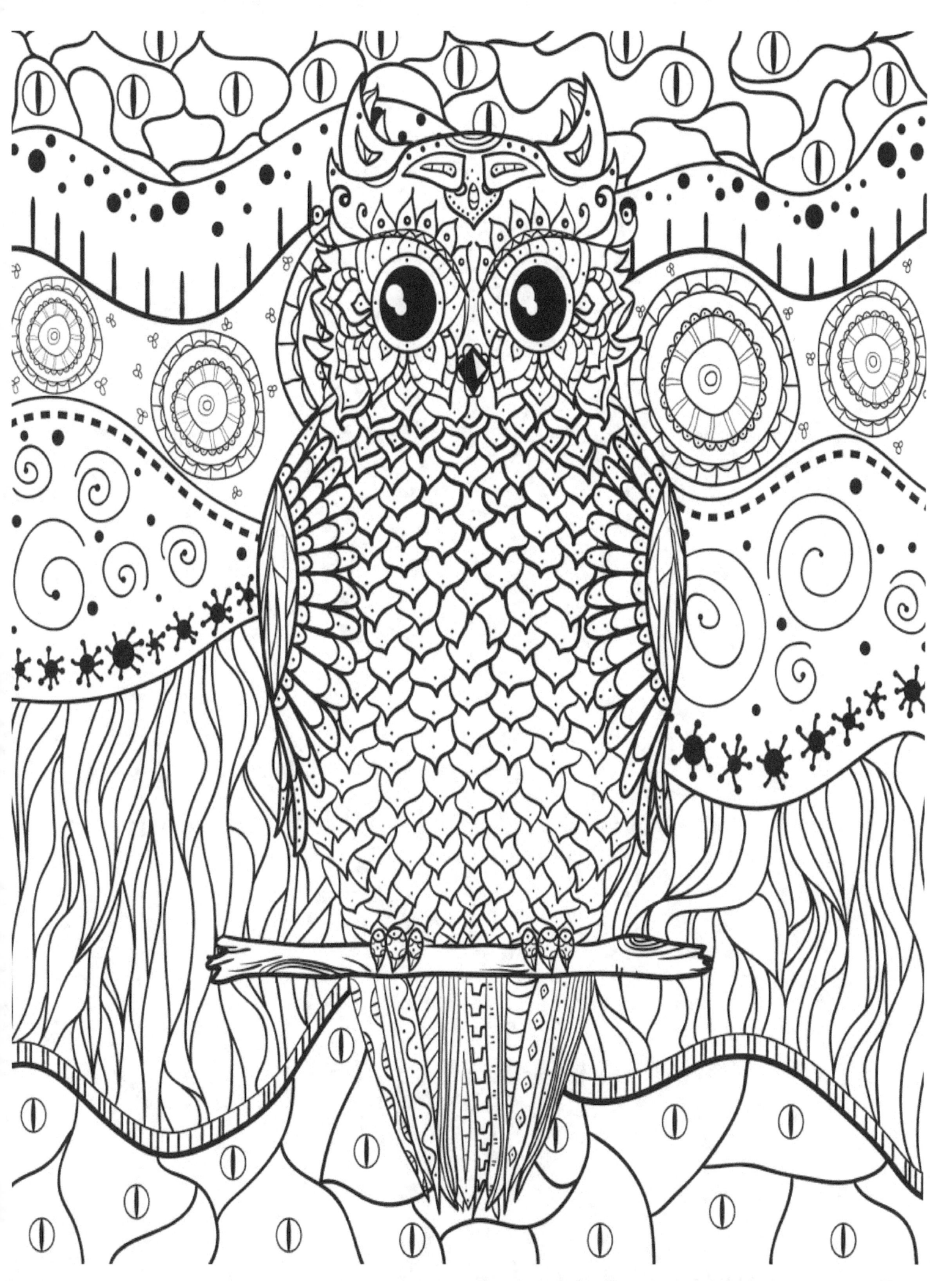

Coloring Test Page

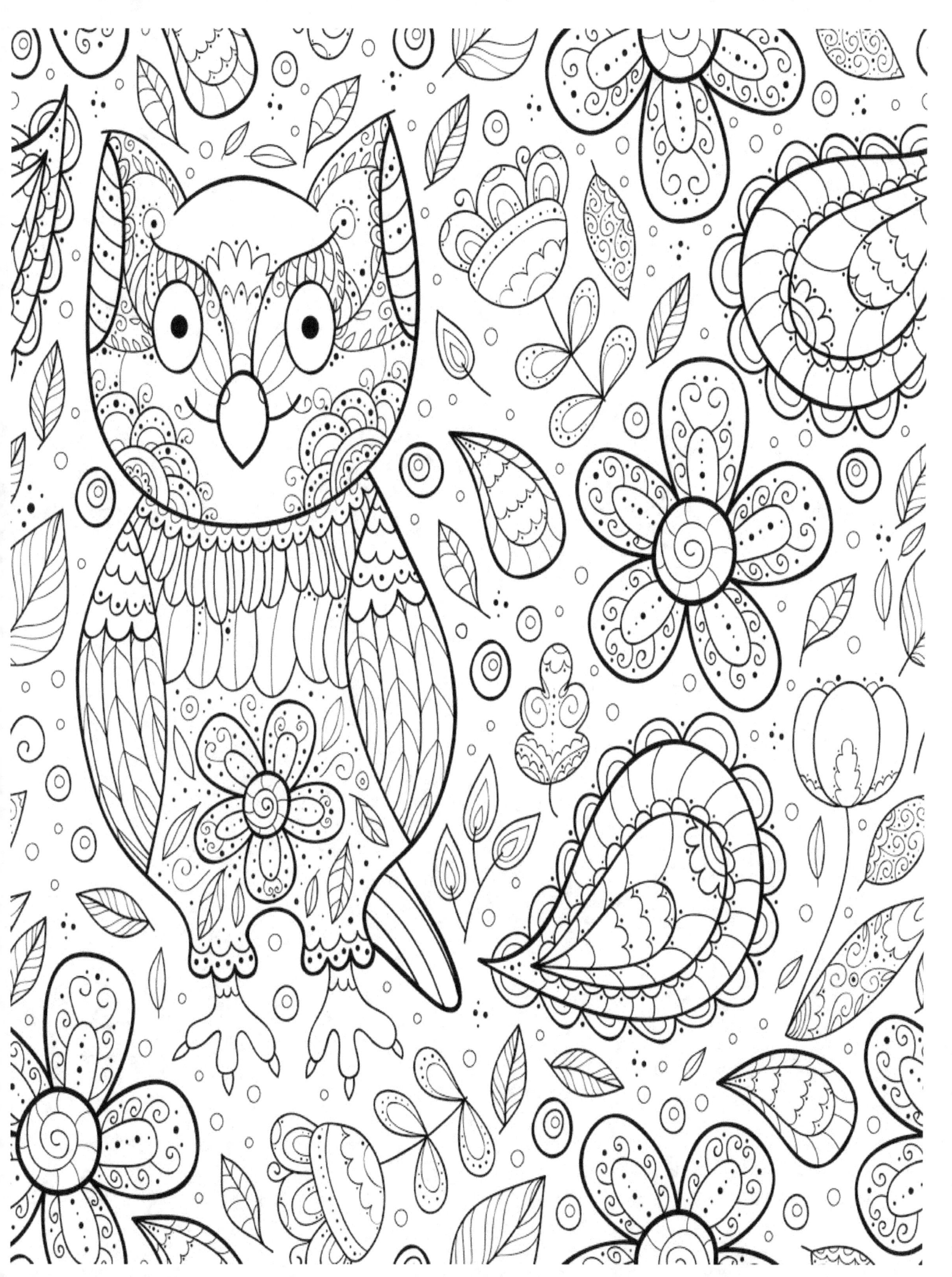

Coloring Test Page

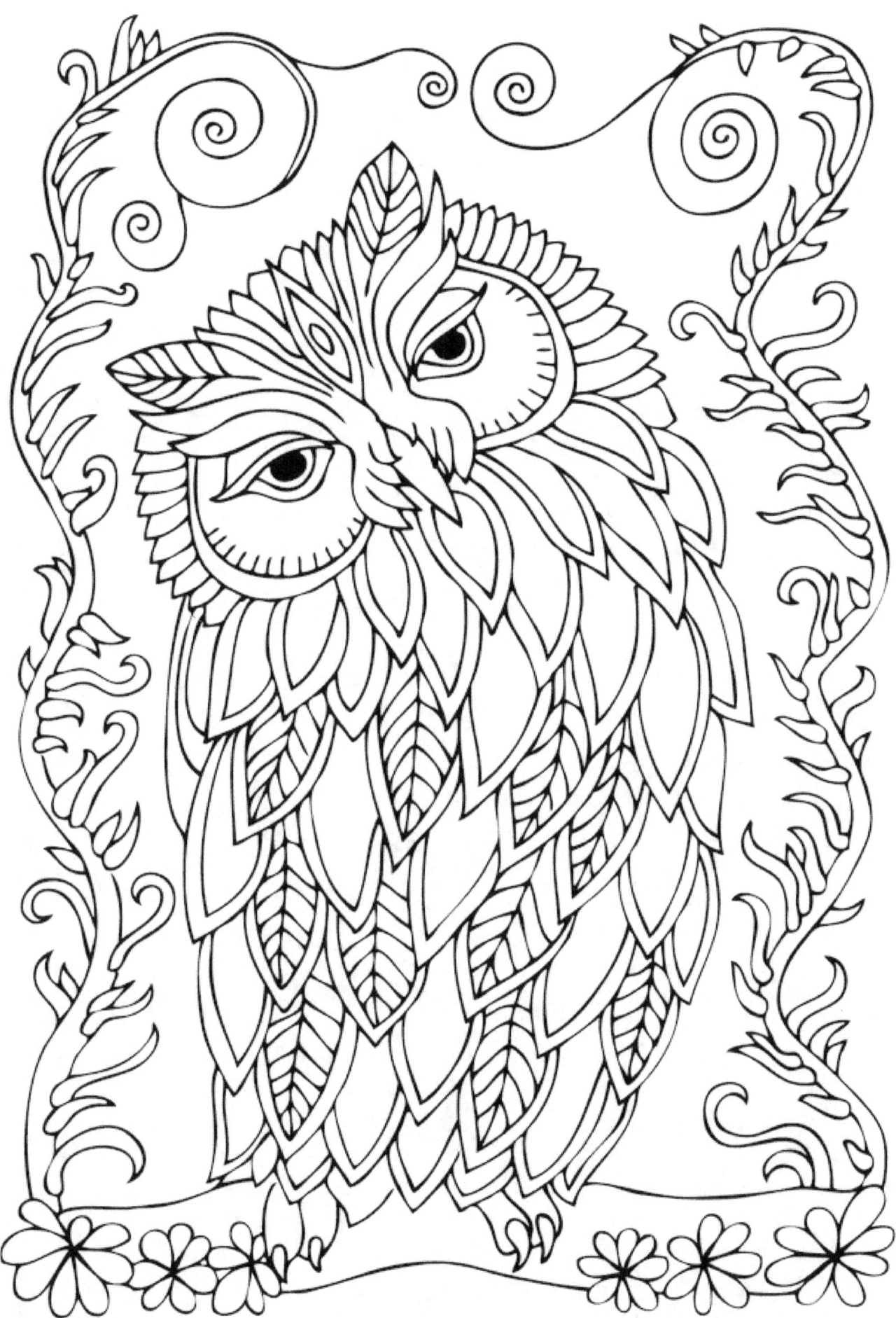

Coloring Test Page

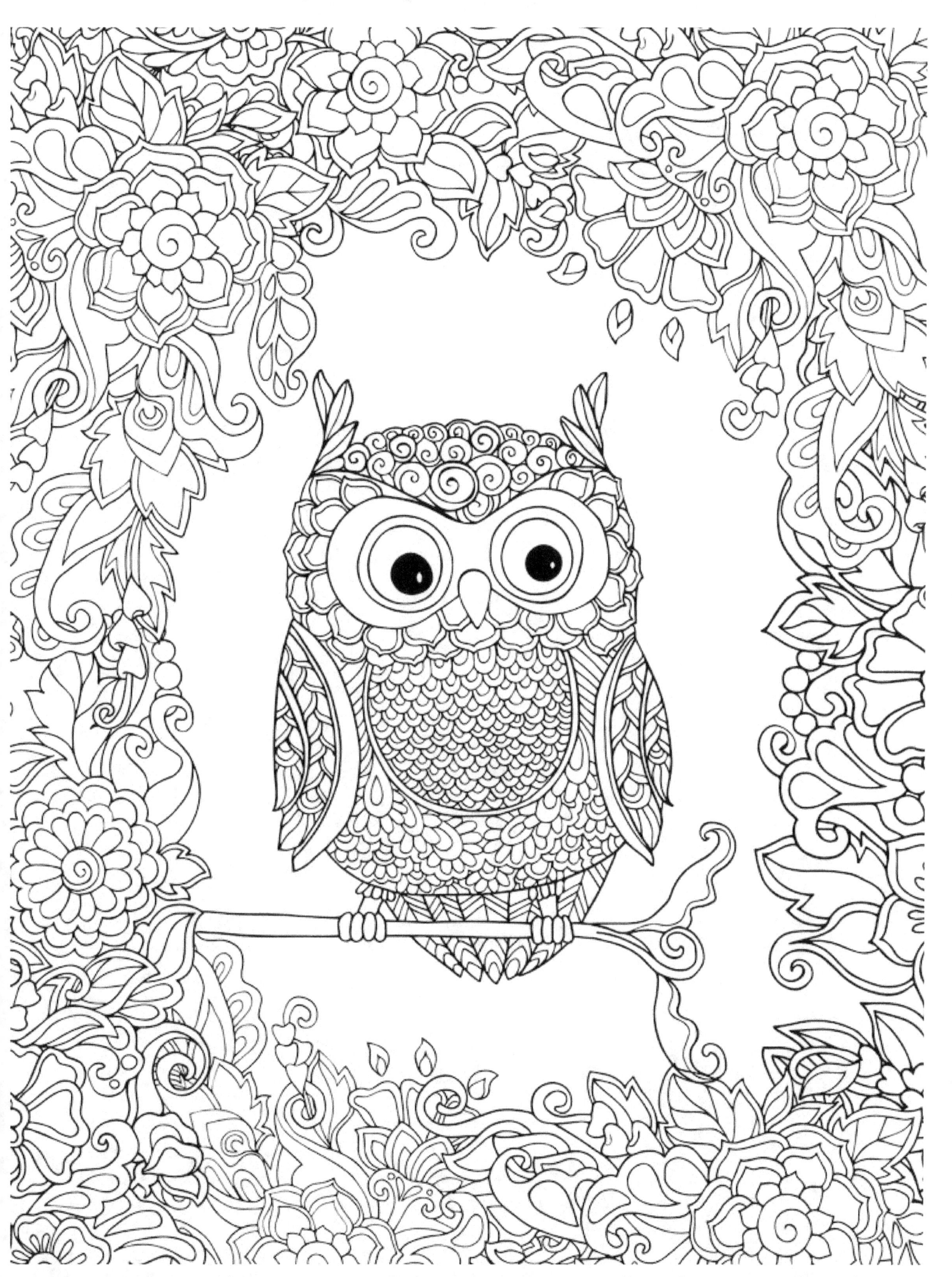

Coloring Test Page

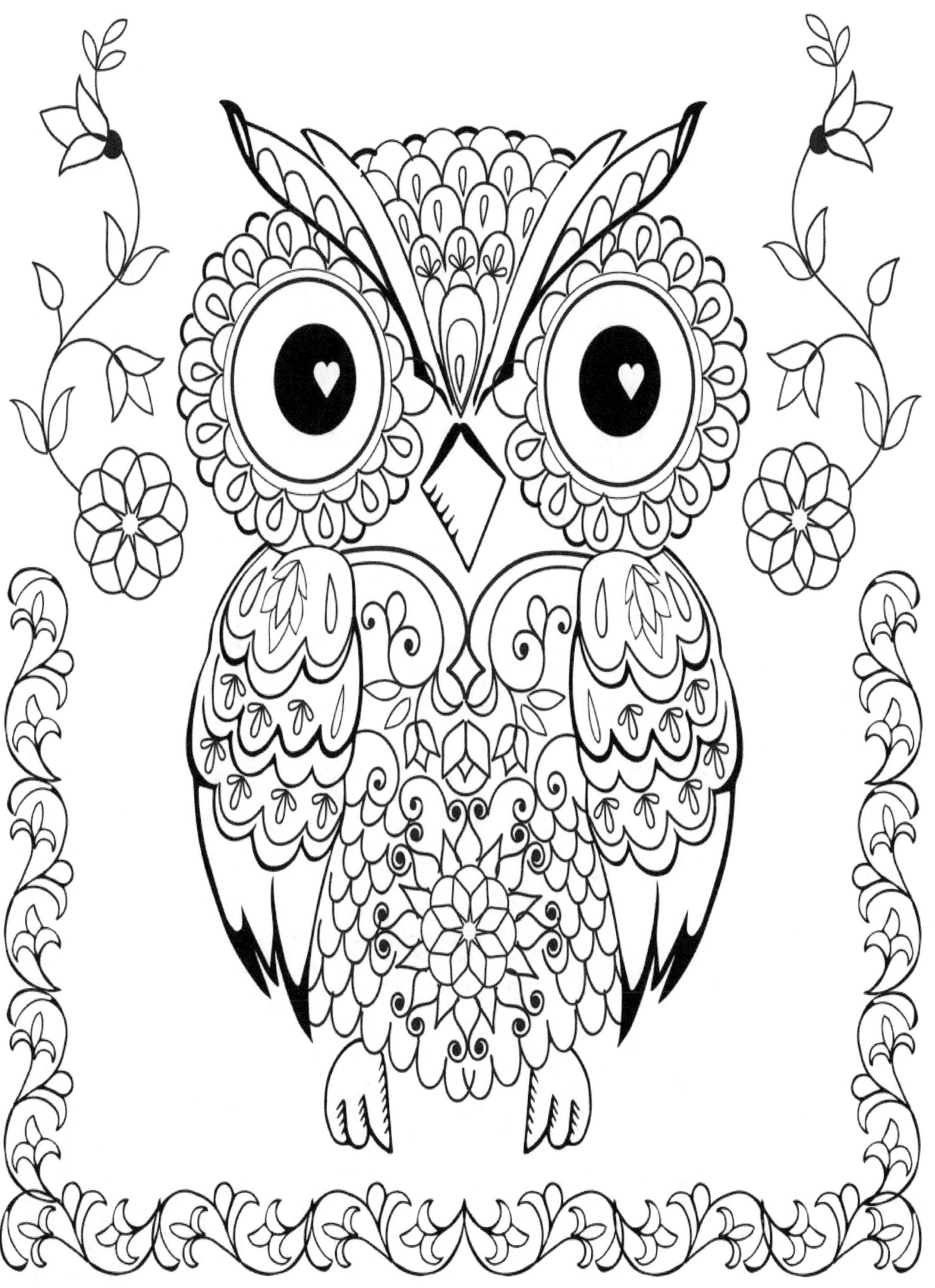

Coloring Test Page

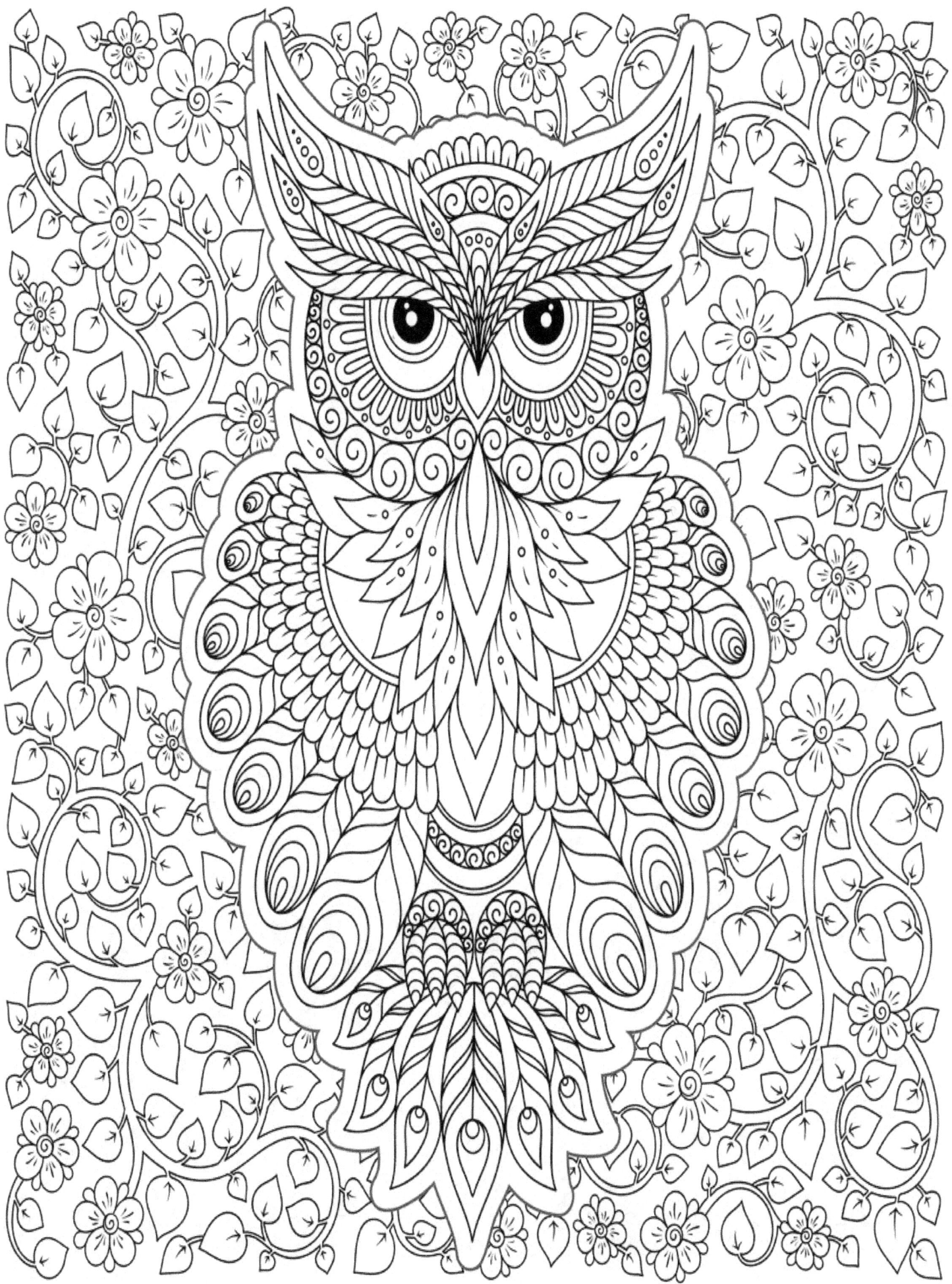

Coloring Test Page

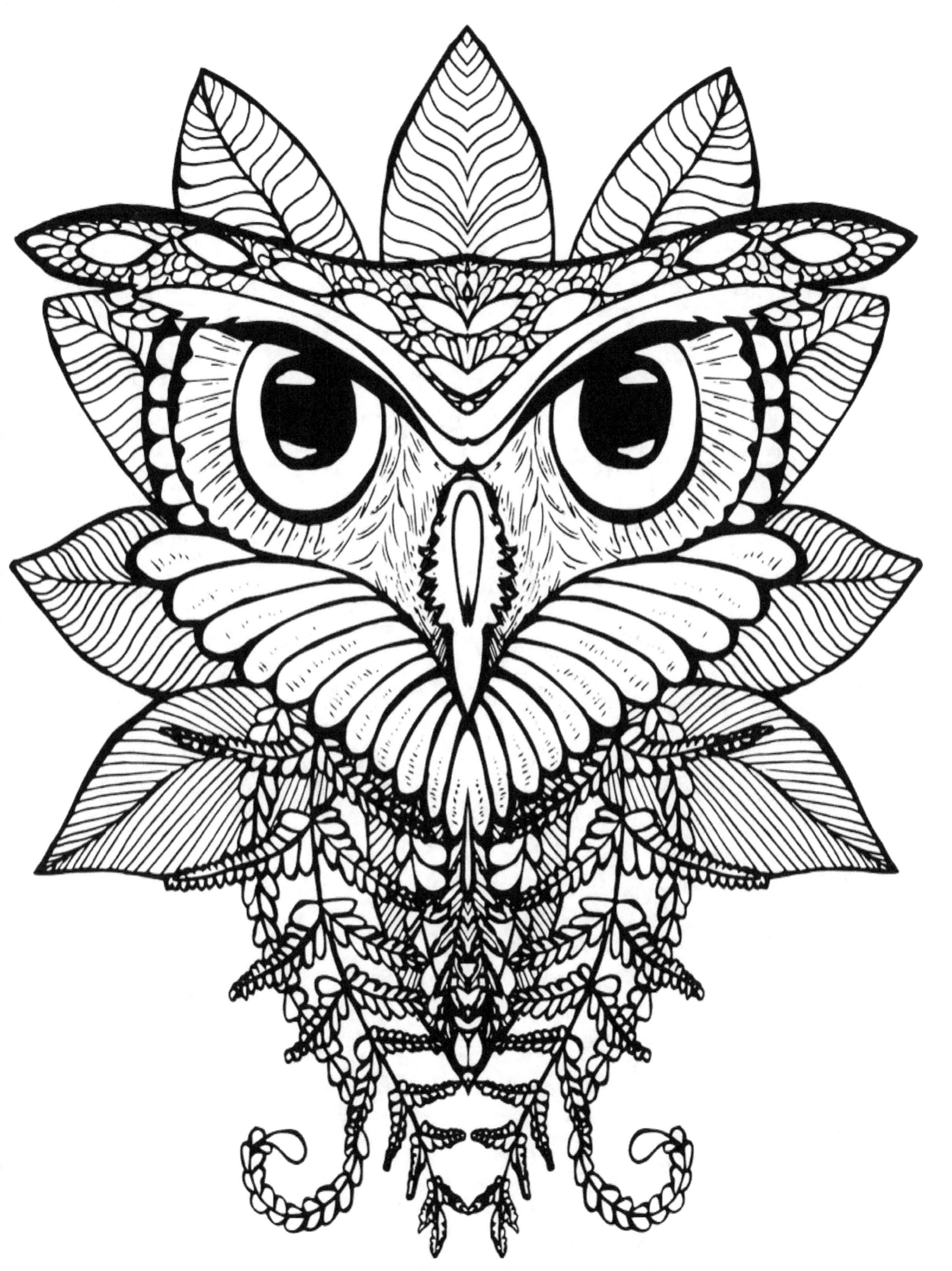

Coloring Test Page

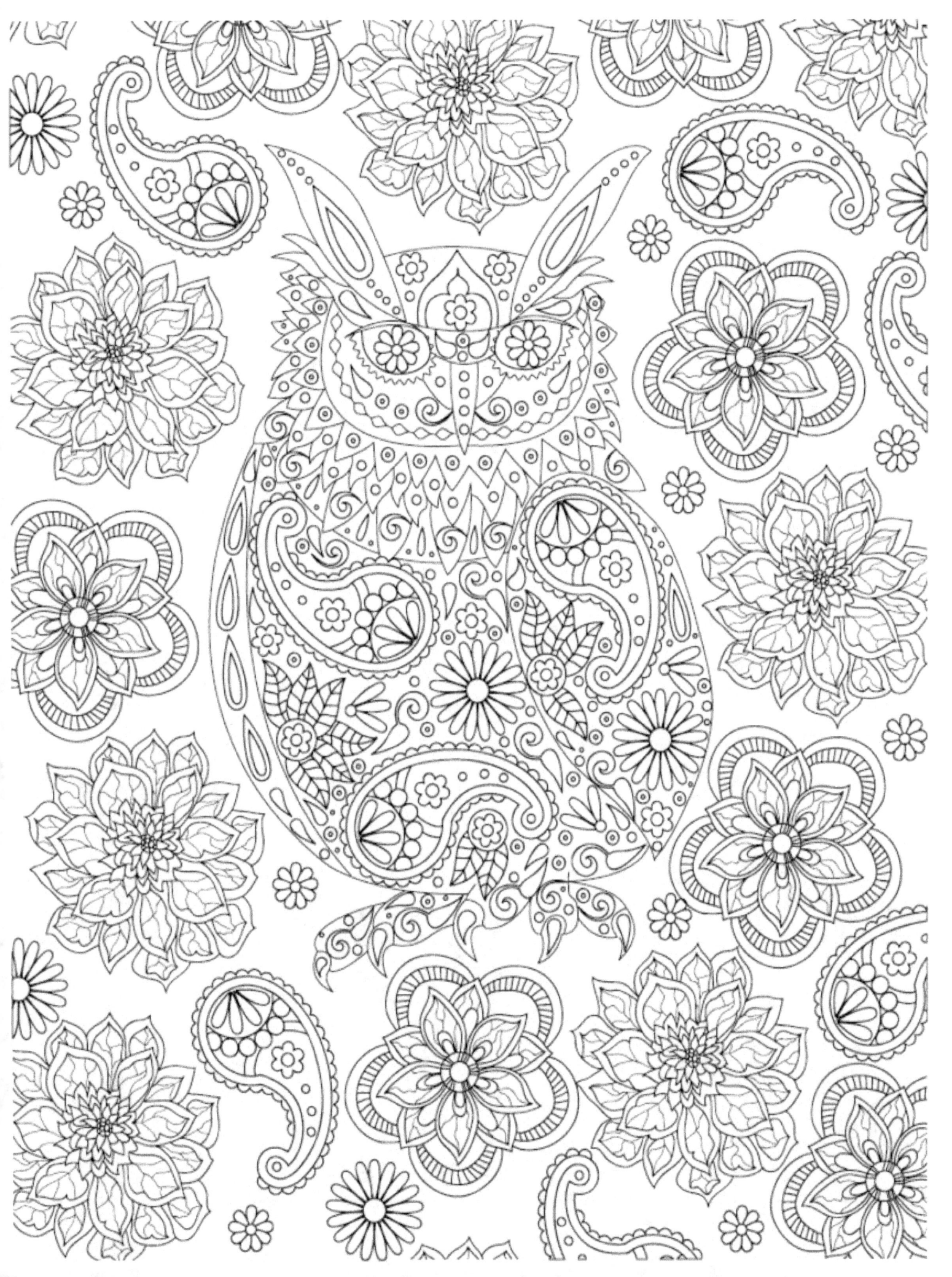

Coloring Test Page

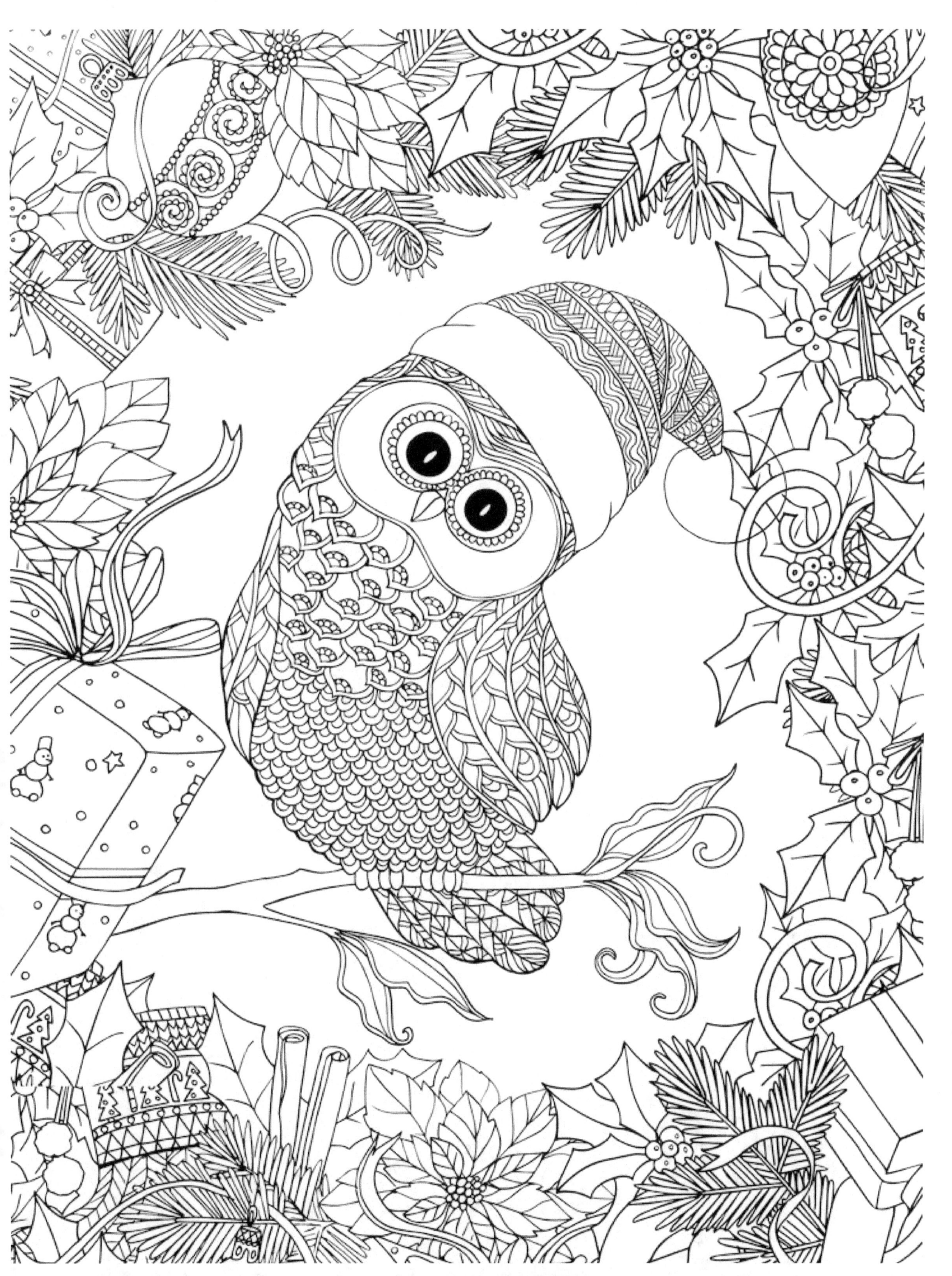

Coloring Test Page

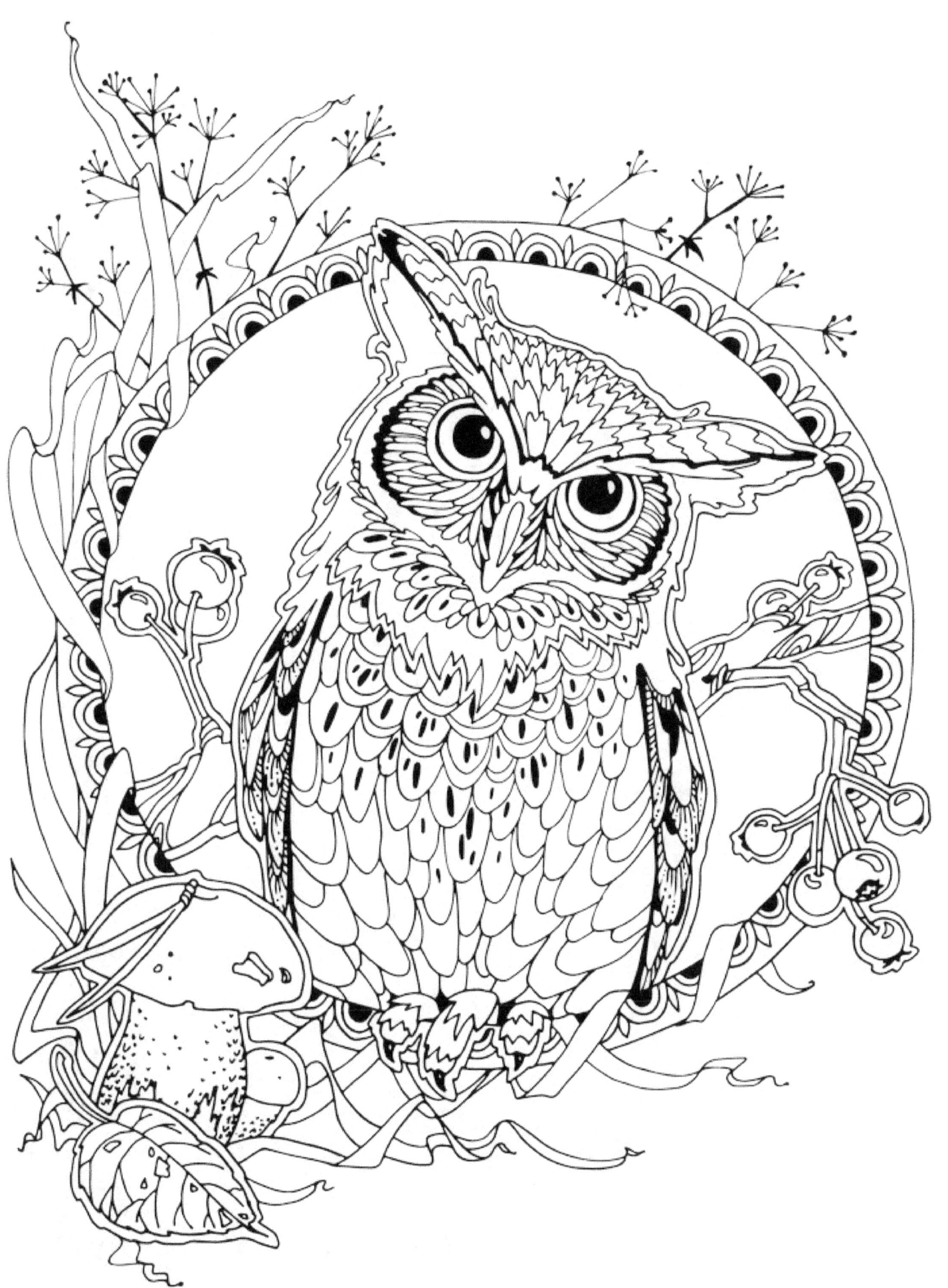

Coloring Test Page

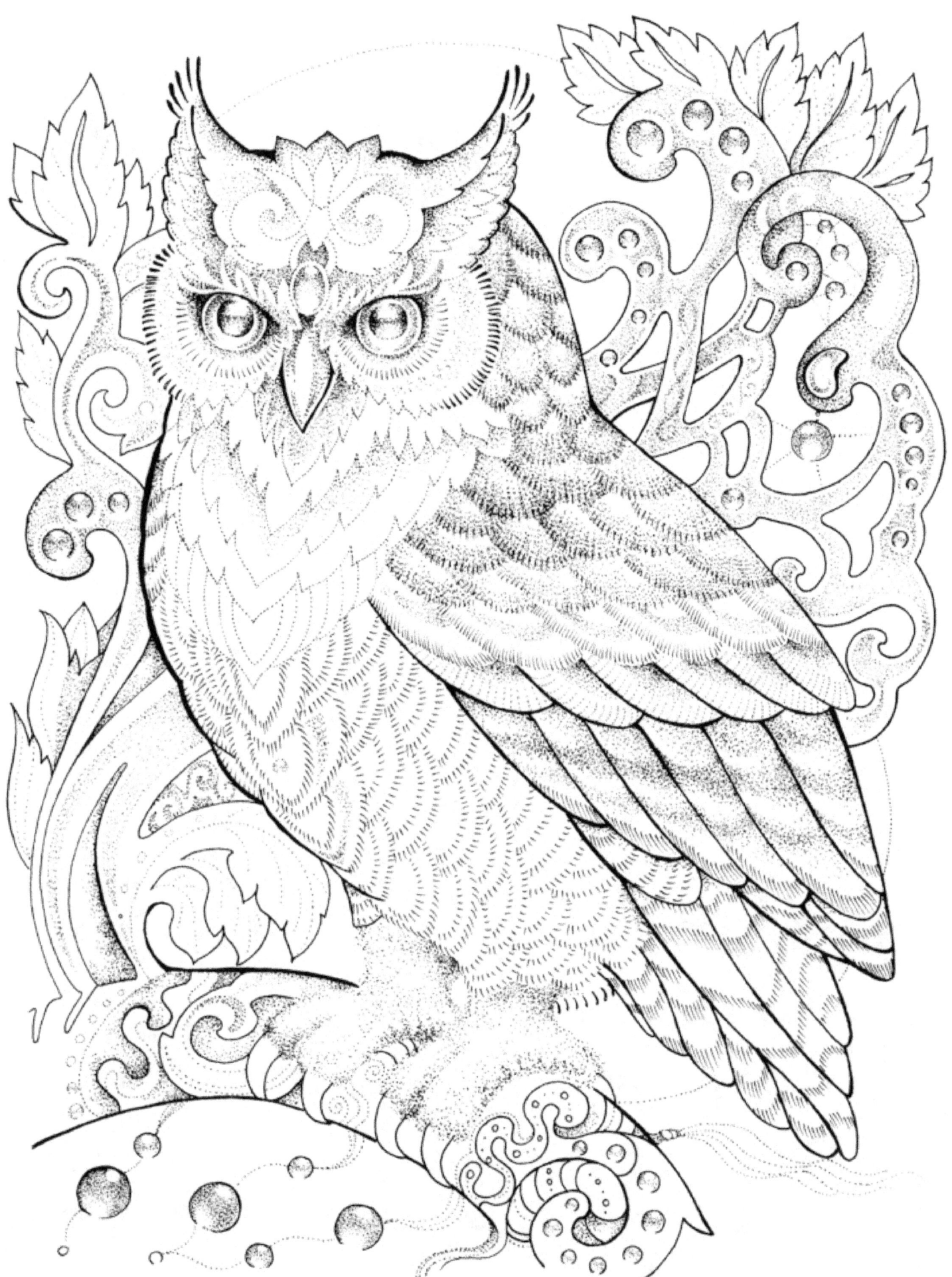

Coloring Test Page

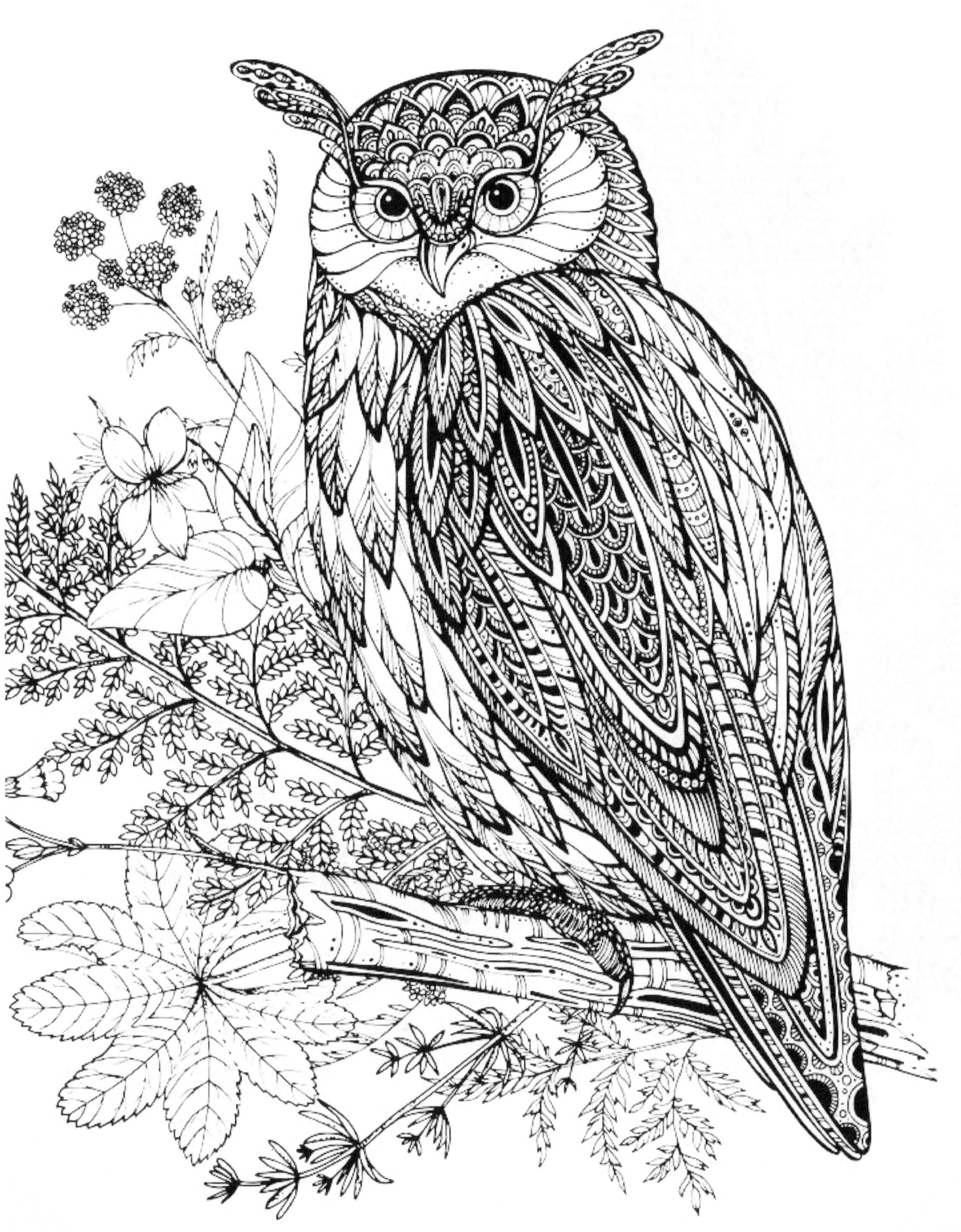

Coloring Test Page

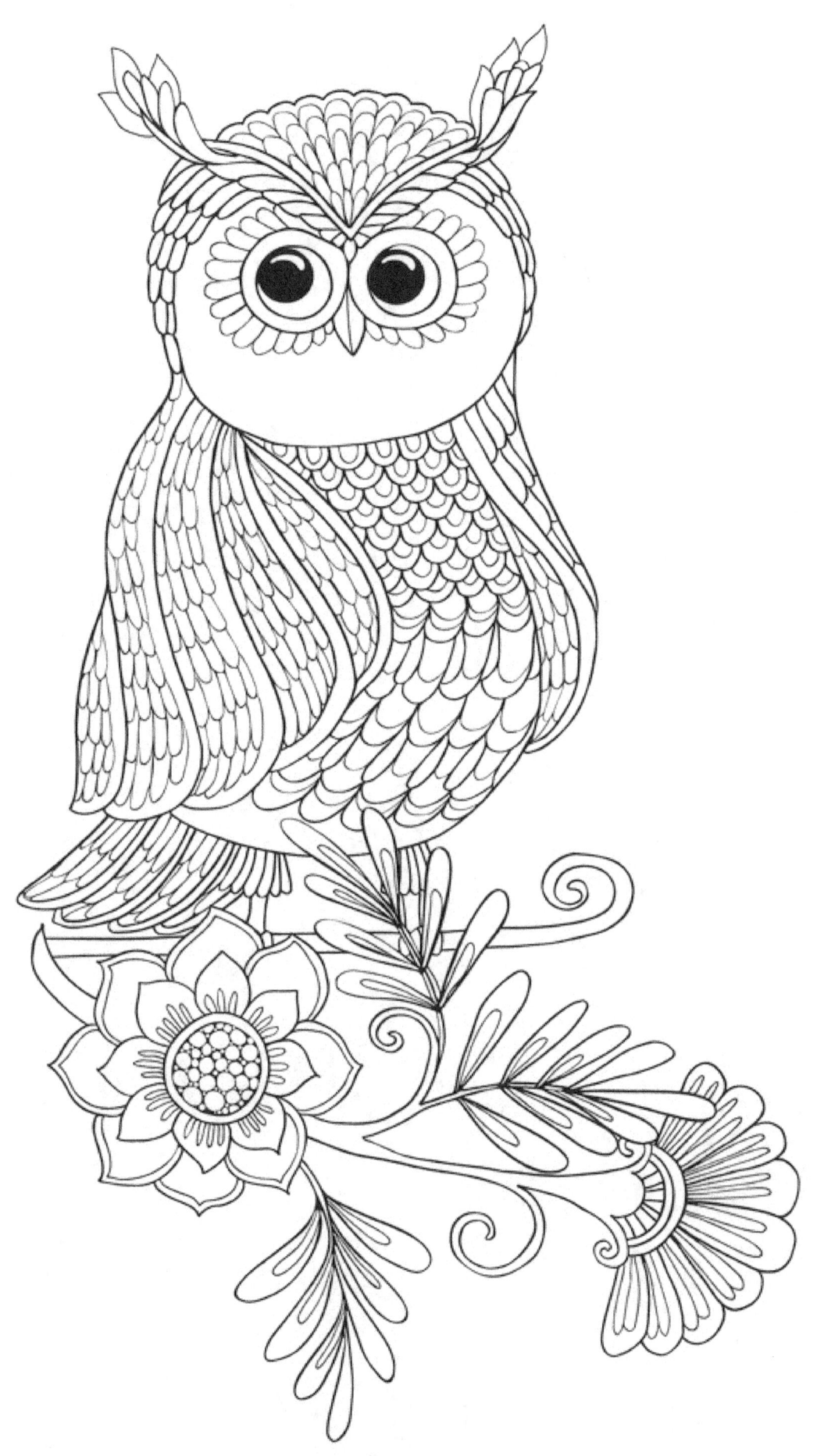

Coloring Test Page

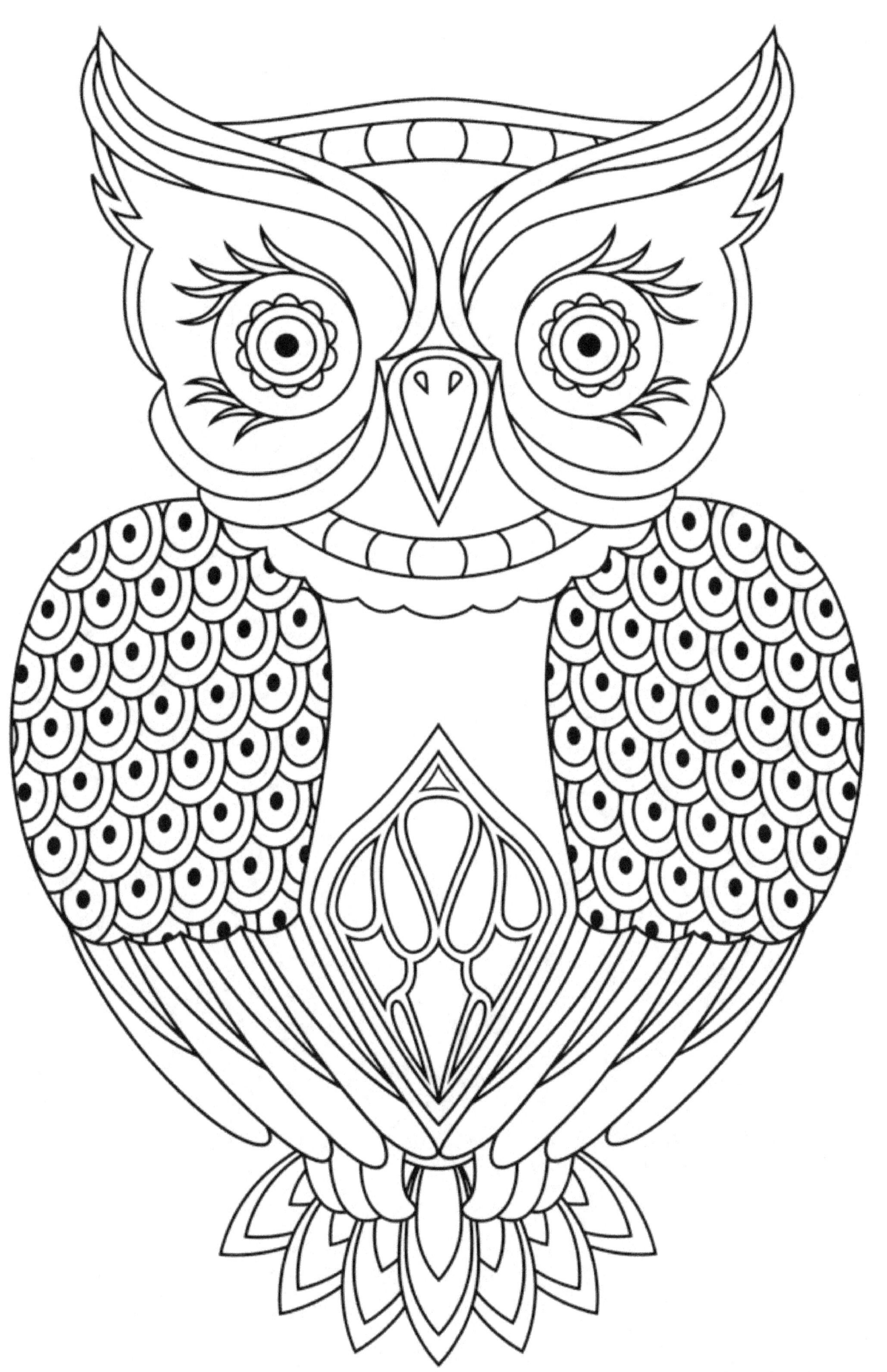

Coloring Test Page

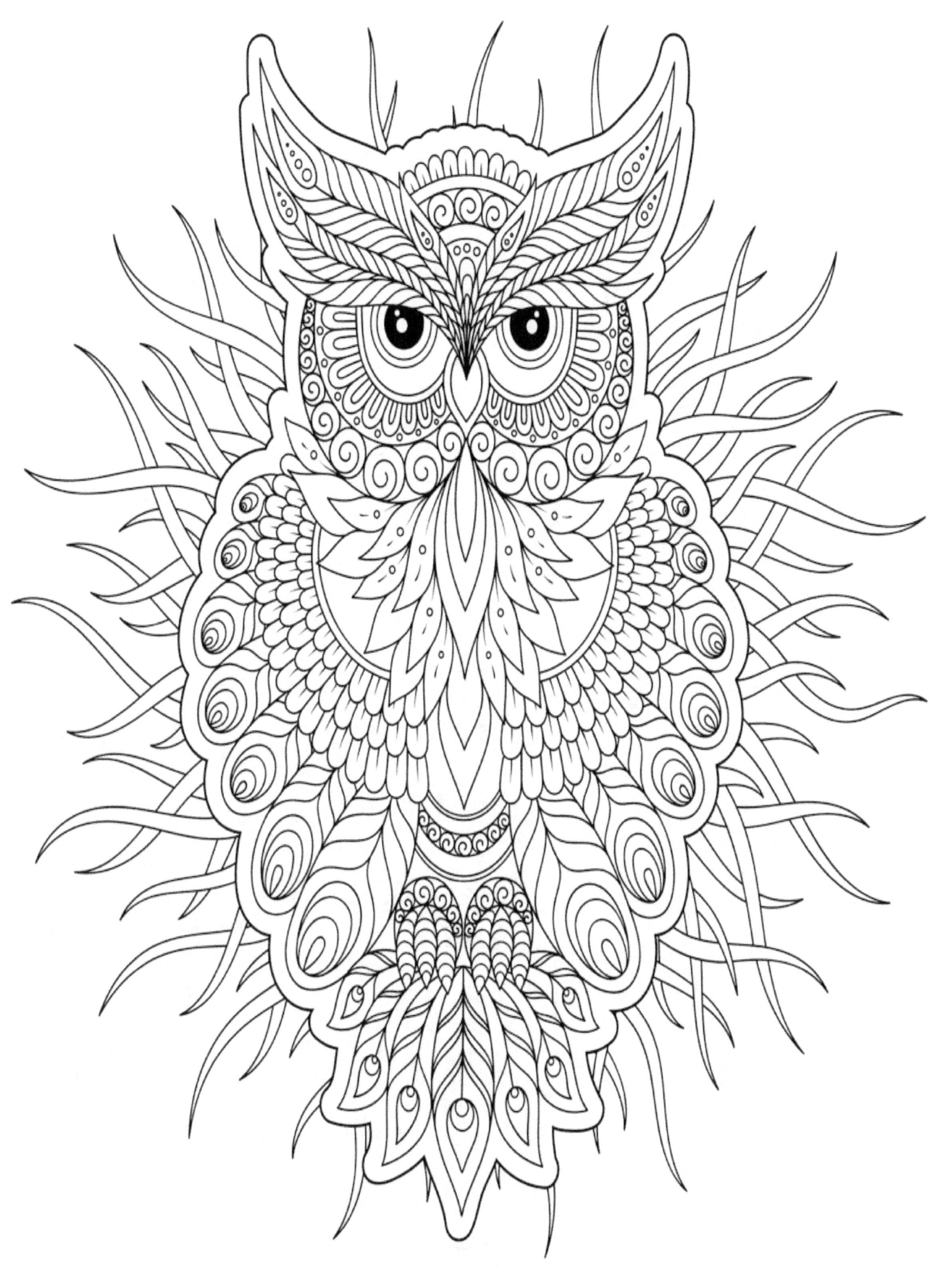

Coloring Test Page

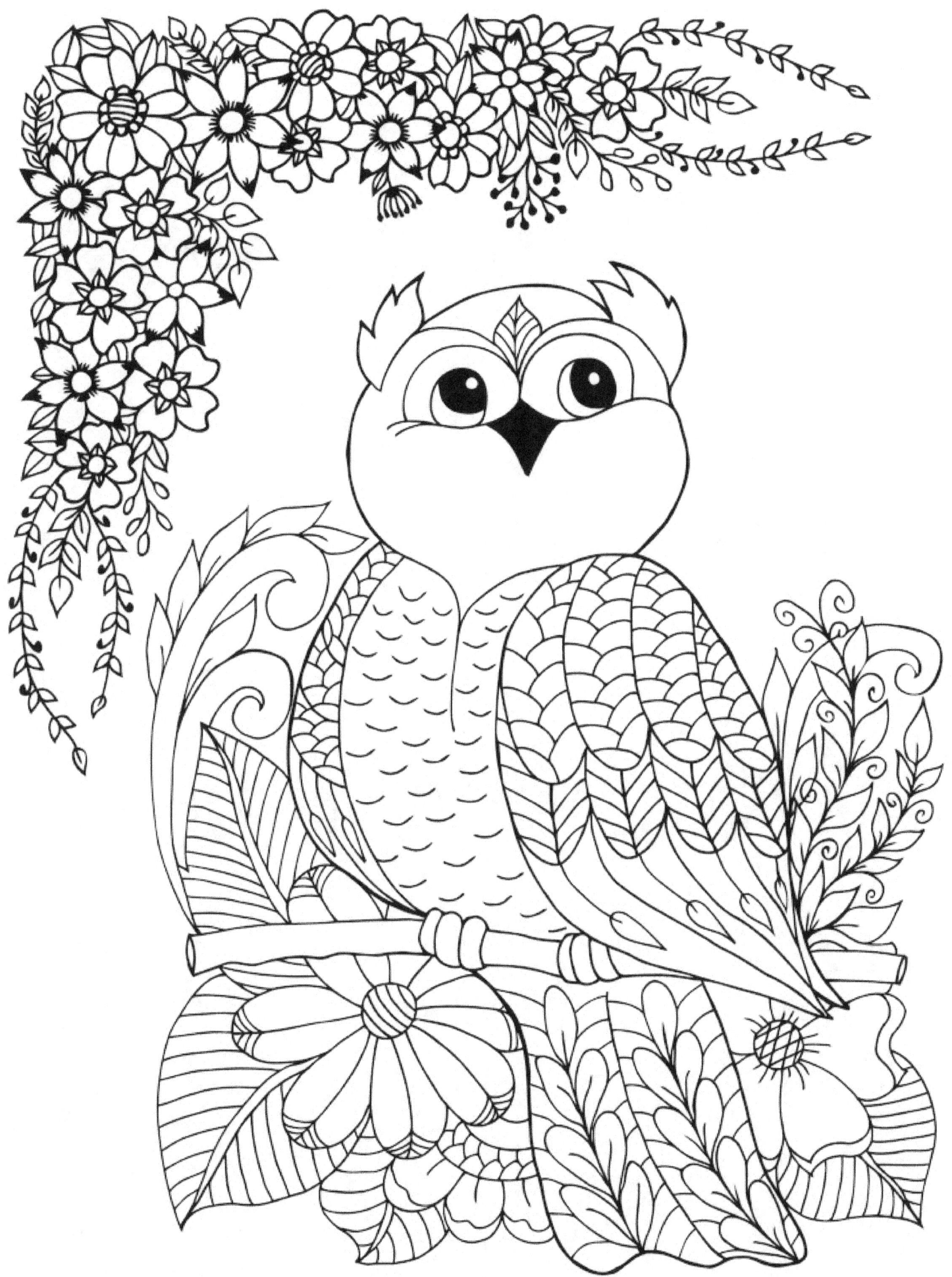

Coloring Test Page

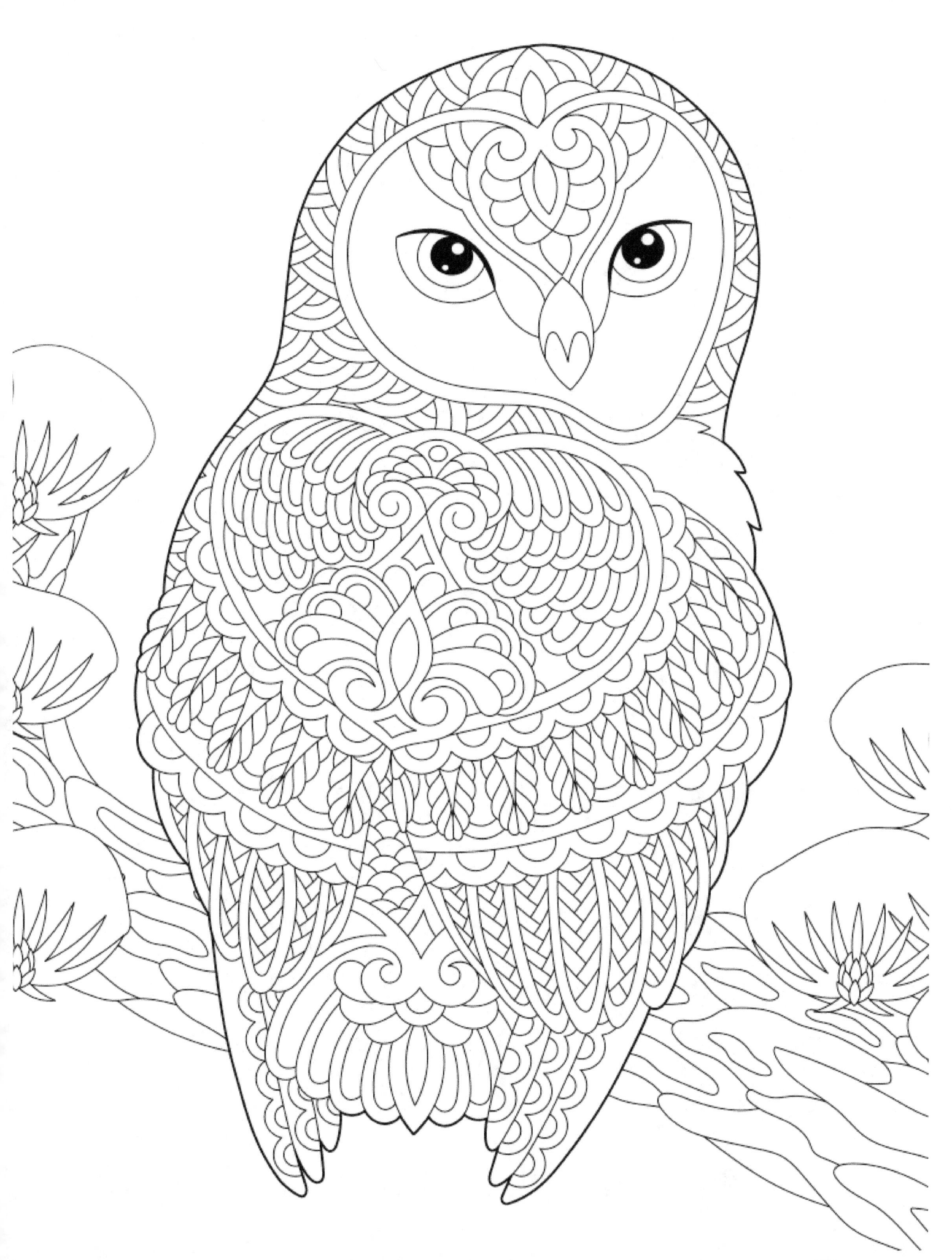

Coloring Test Page

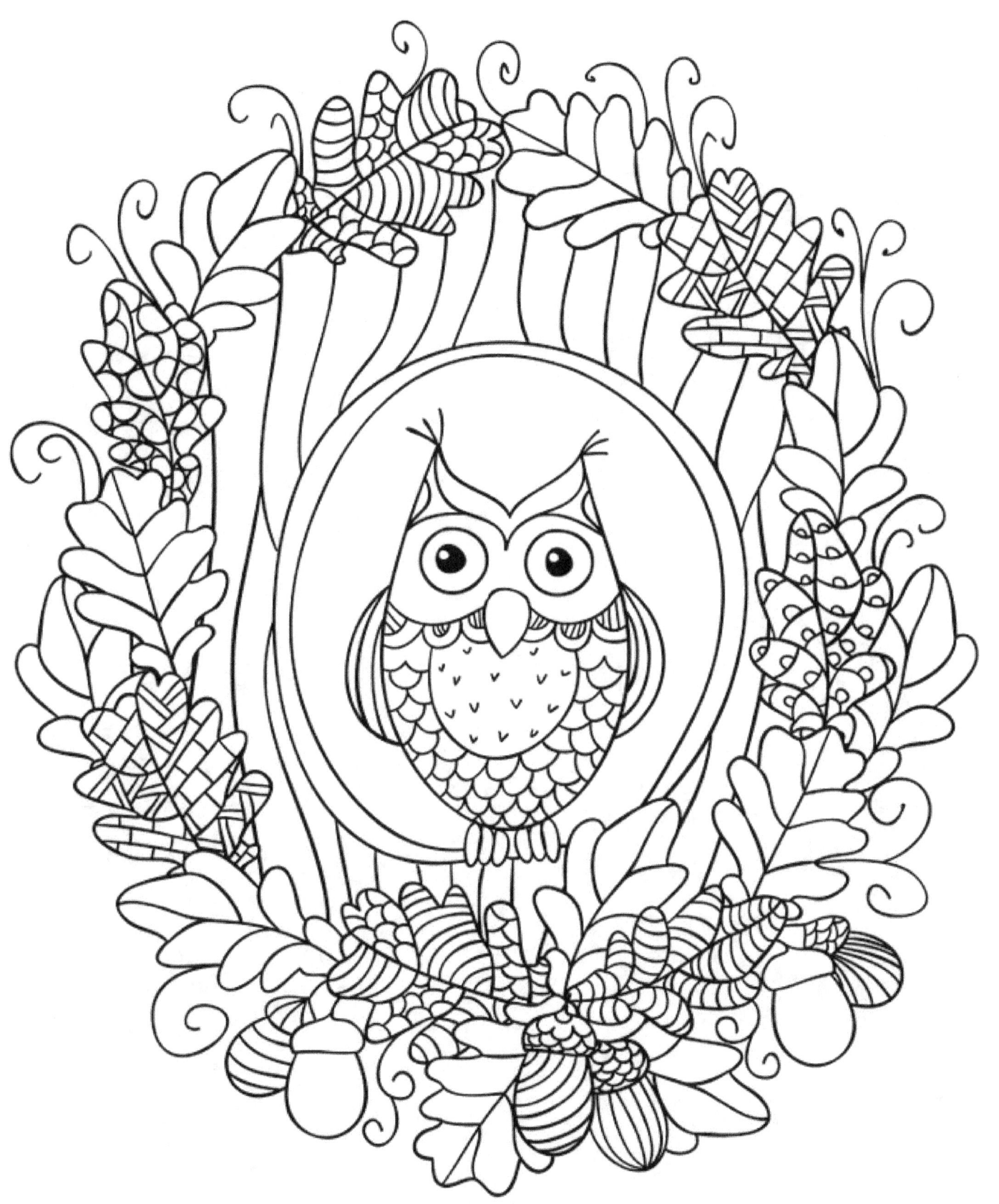

Coloring Test Page

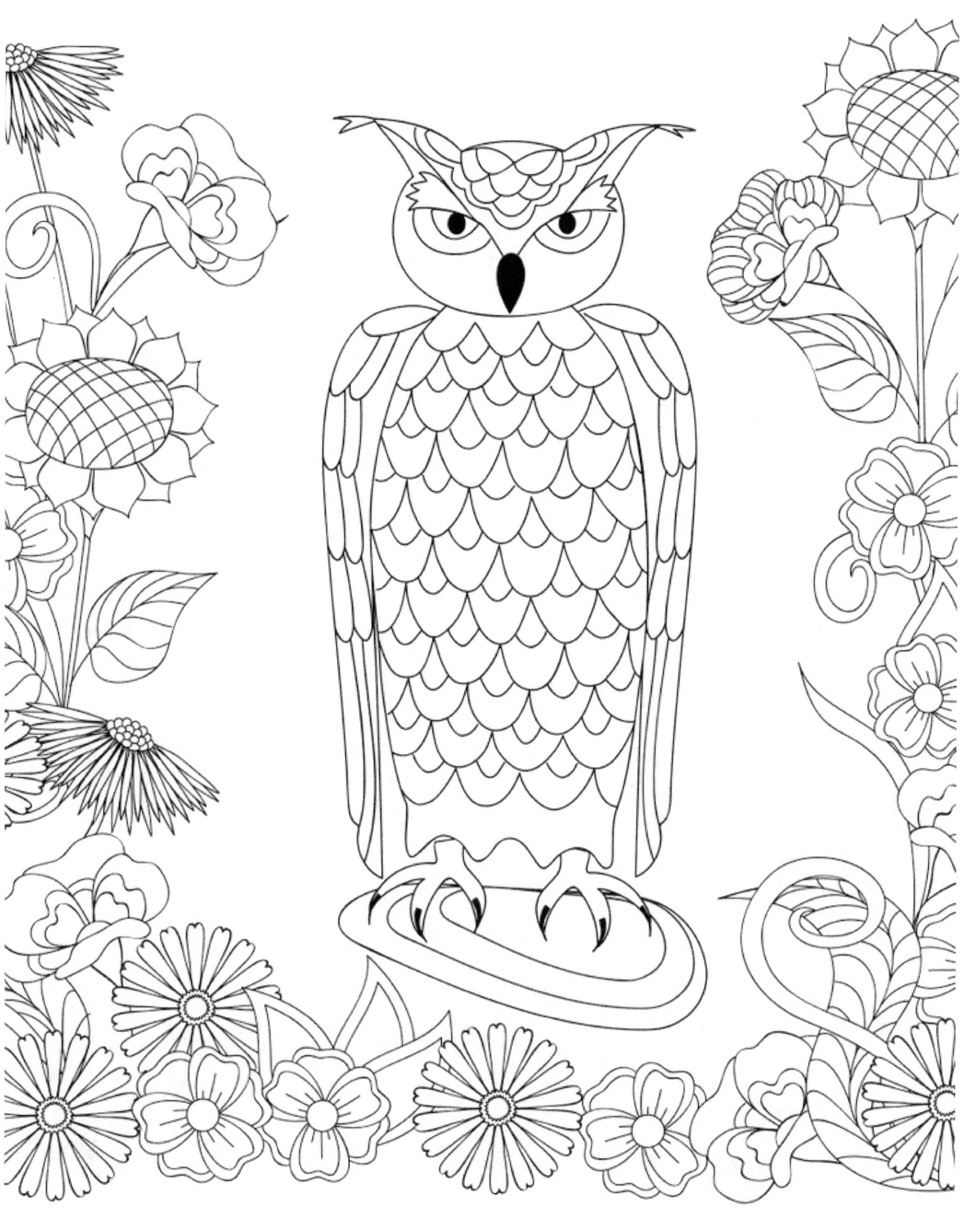

Coloring Test Page

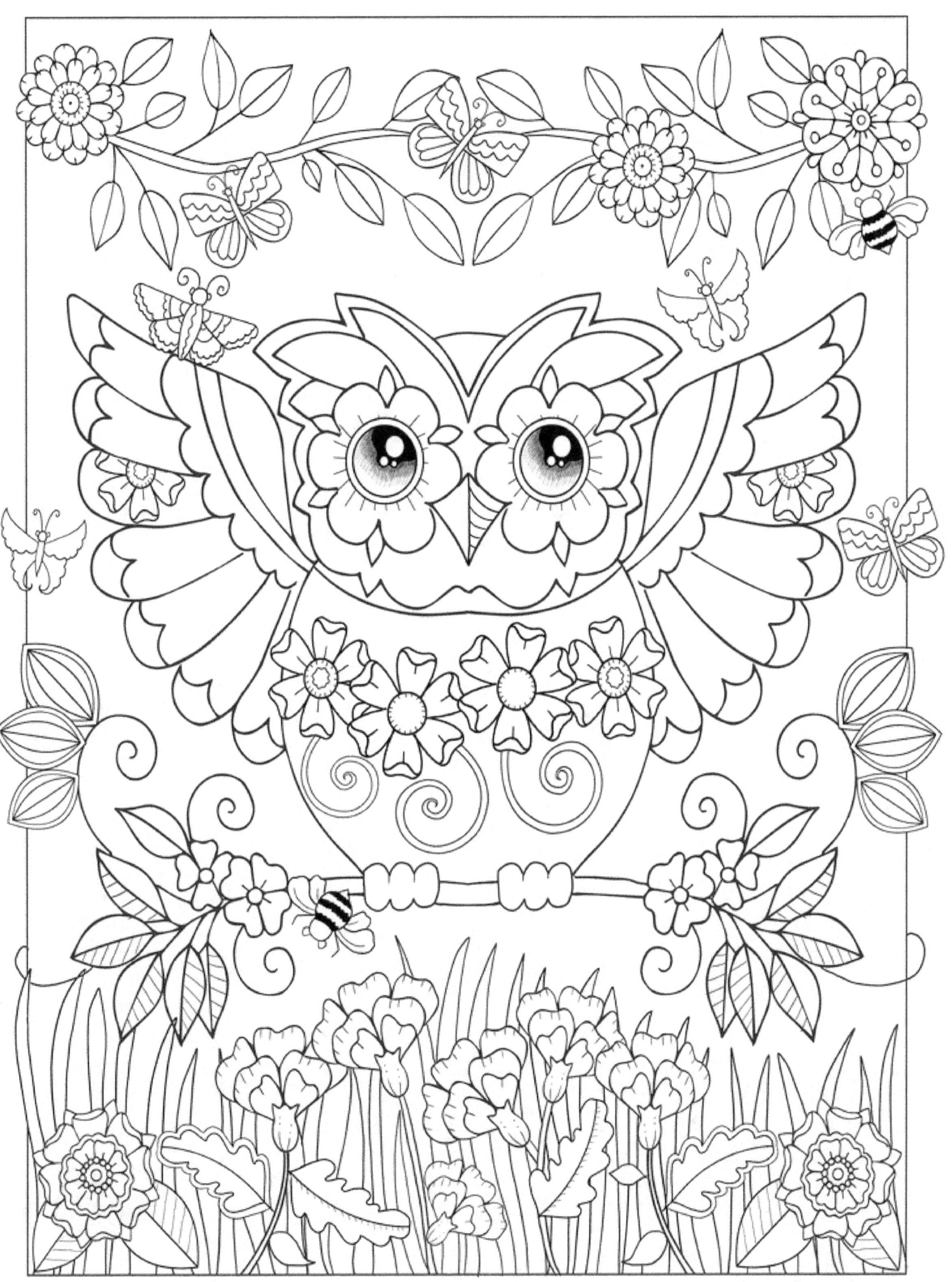

Coloring Test Page

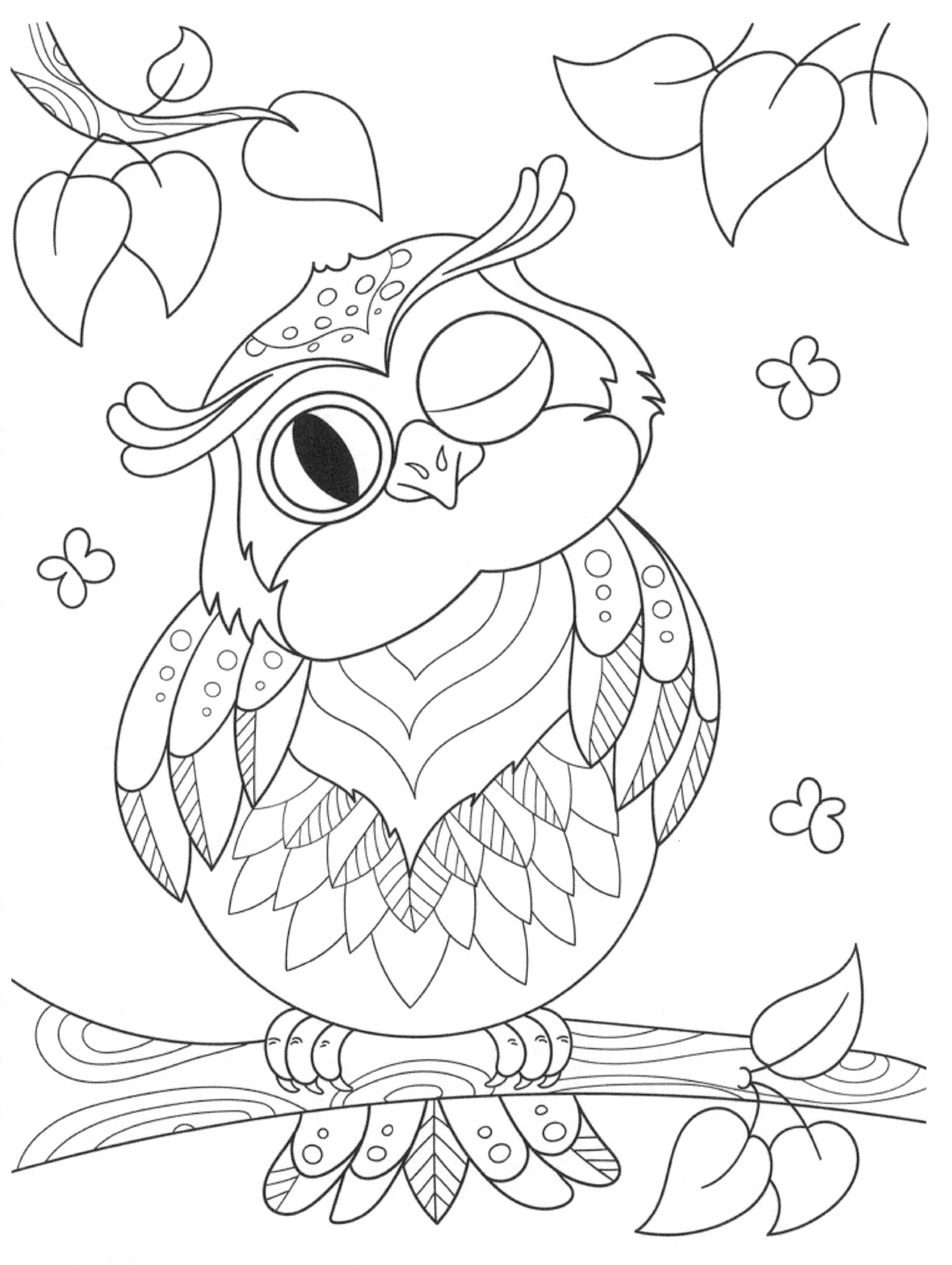

Coloring Test Page

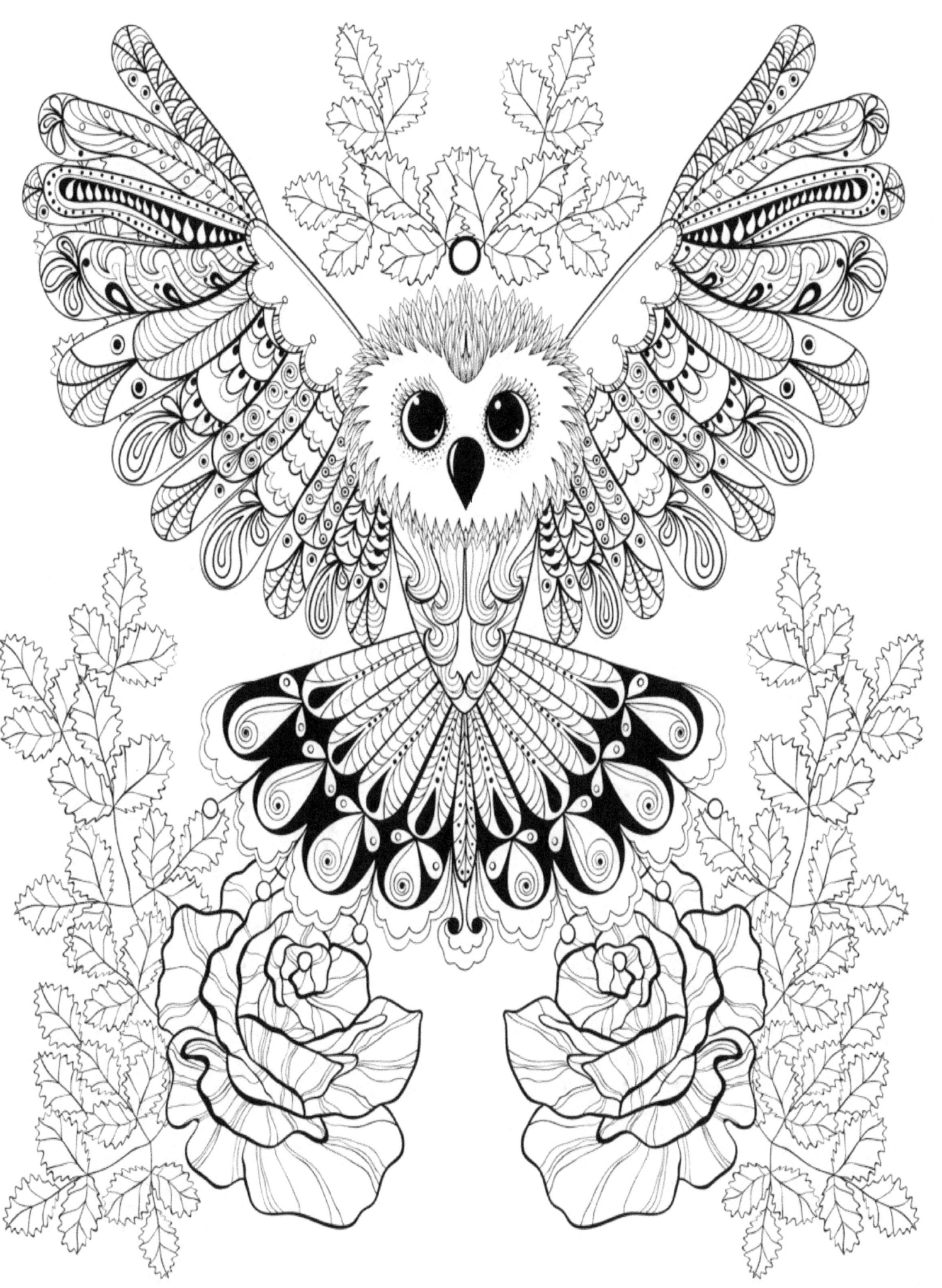

Coloring Test Page

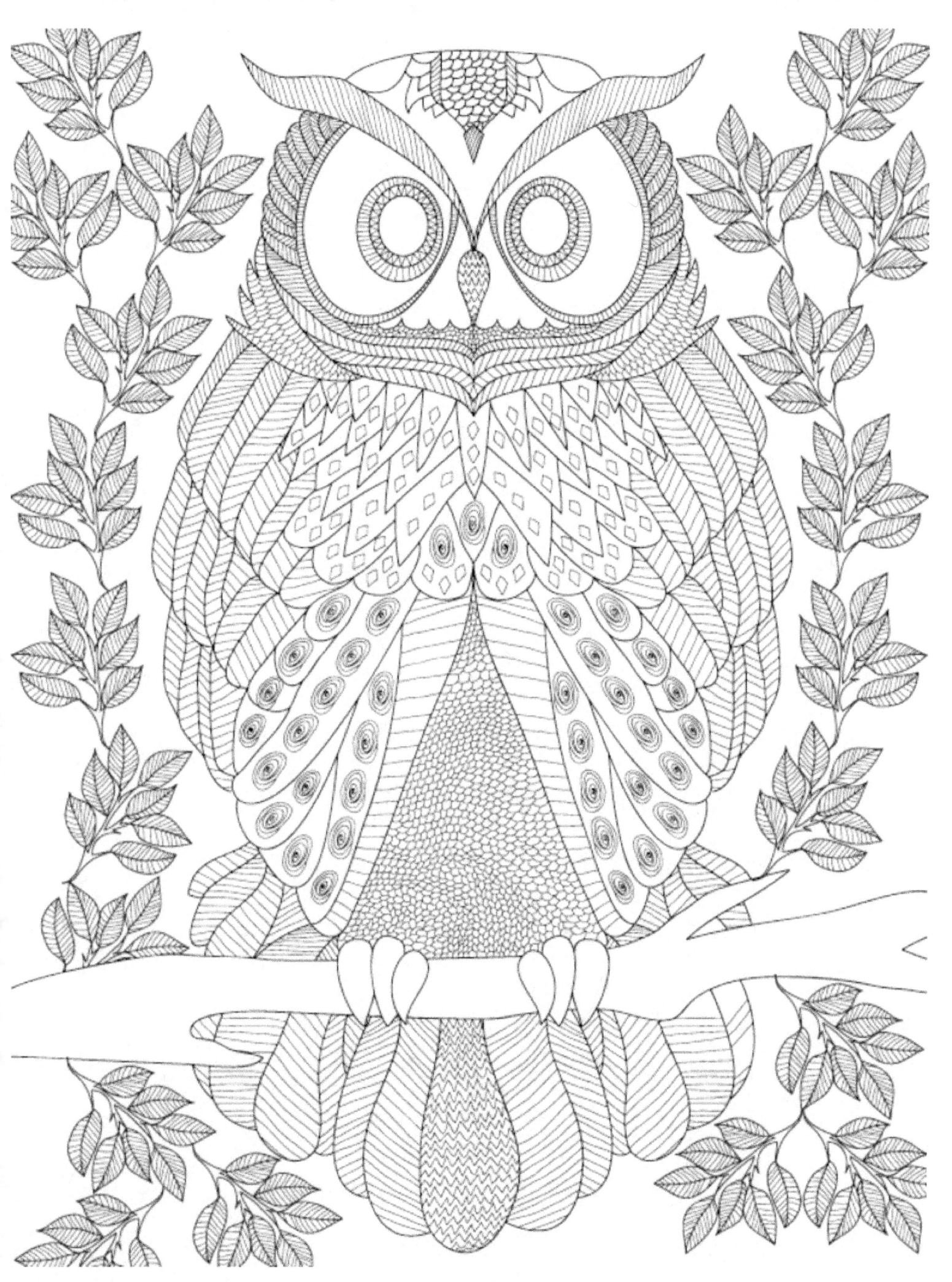

Coloring Test Page

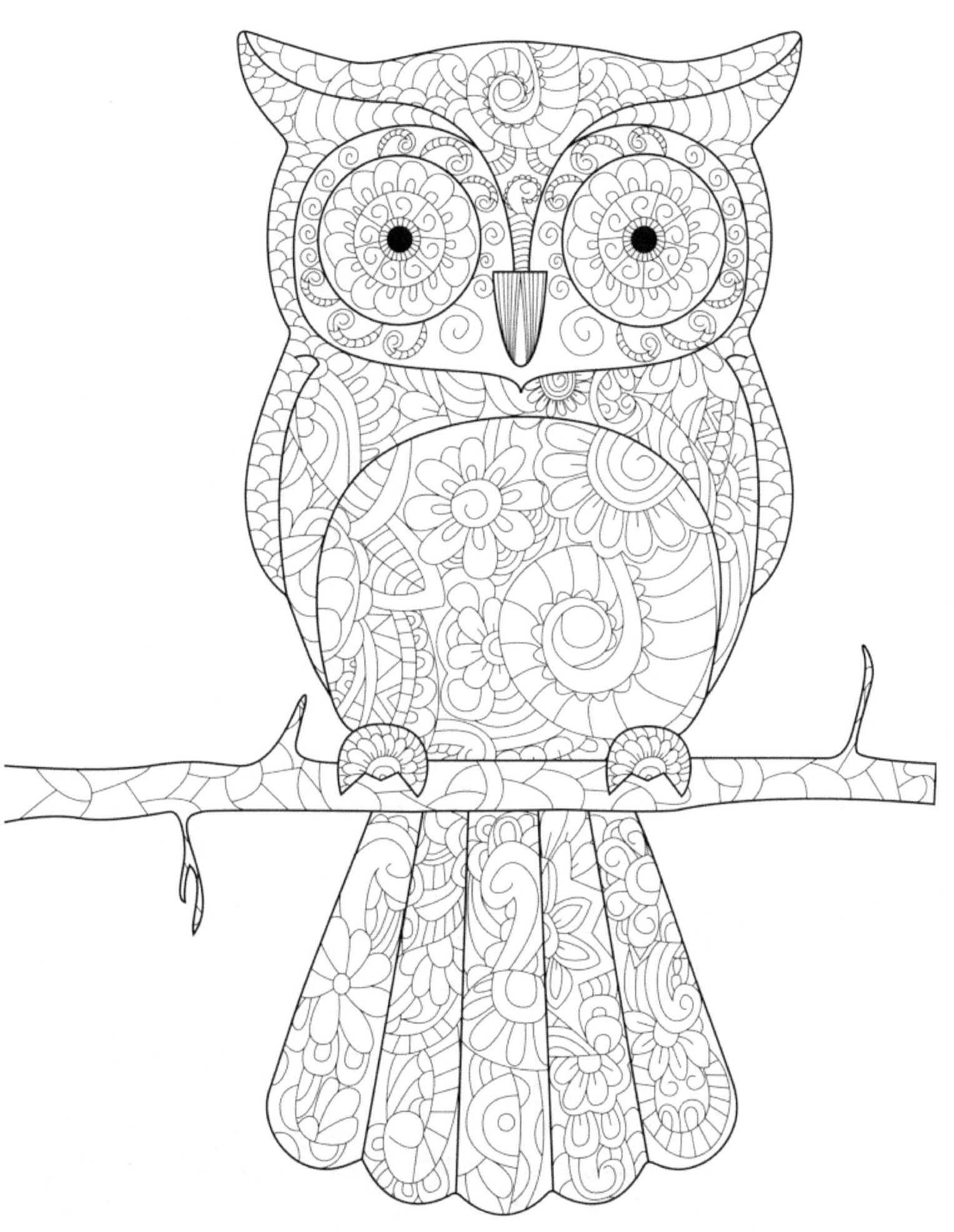

Coloring Test Page

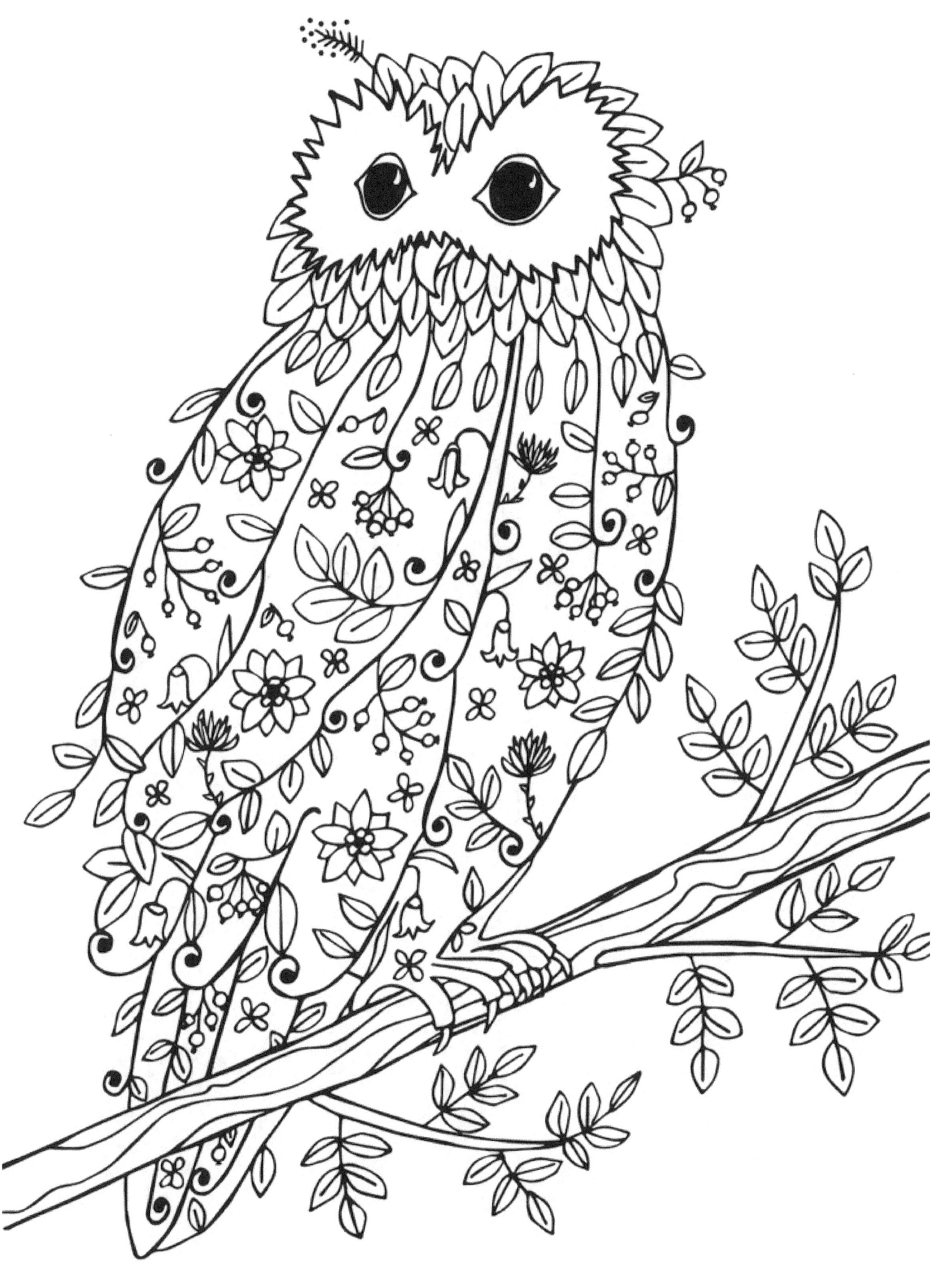

Coloring Test Page

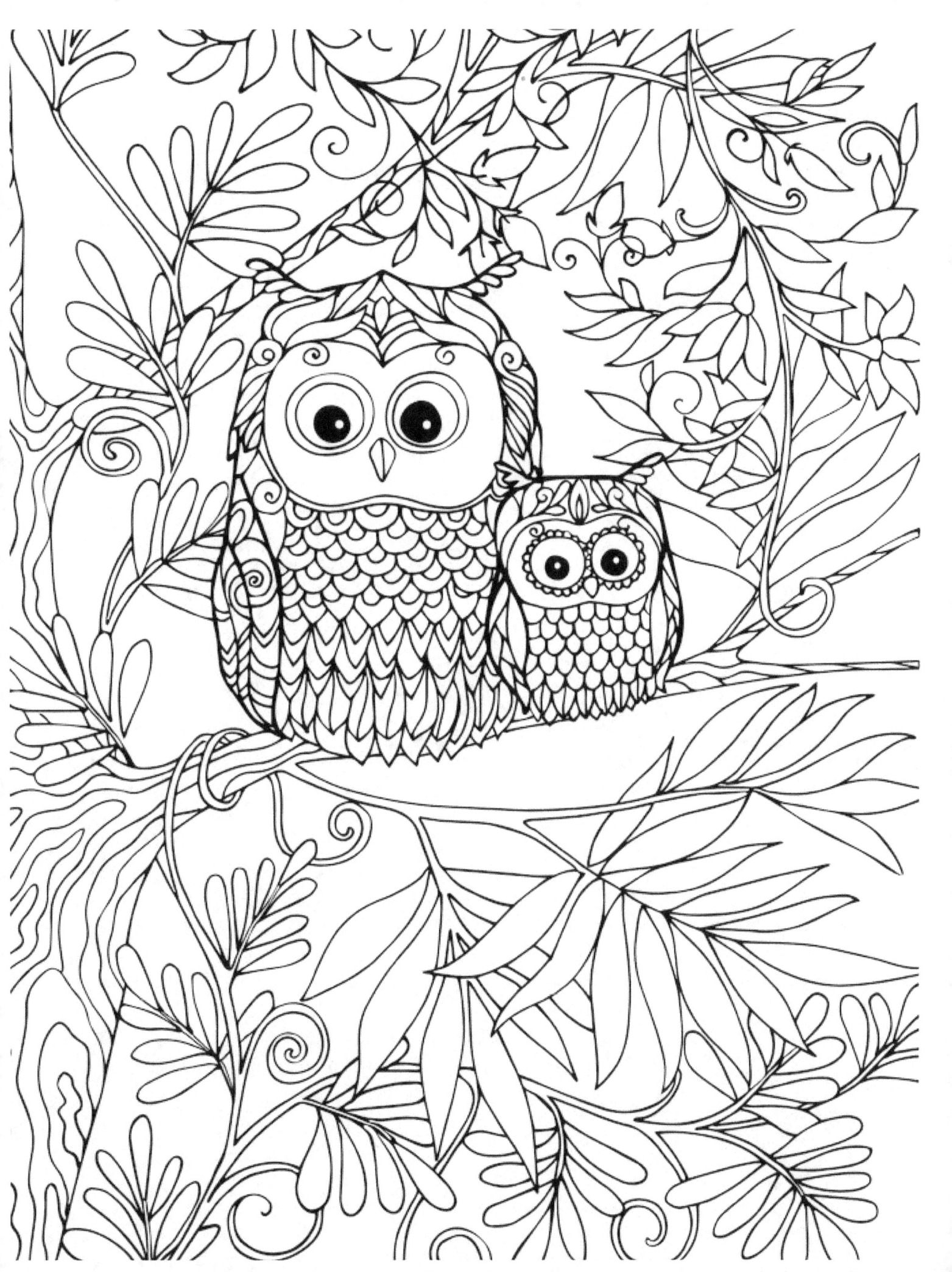

Coloring Test Page

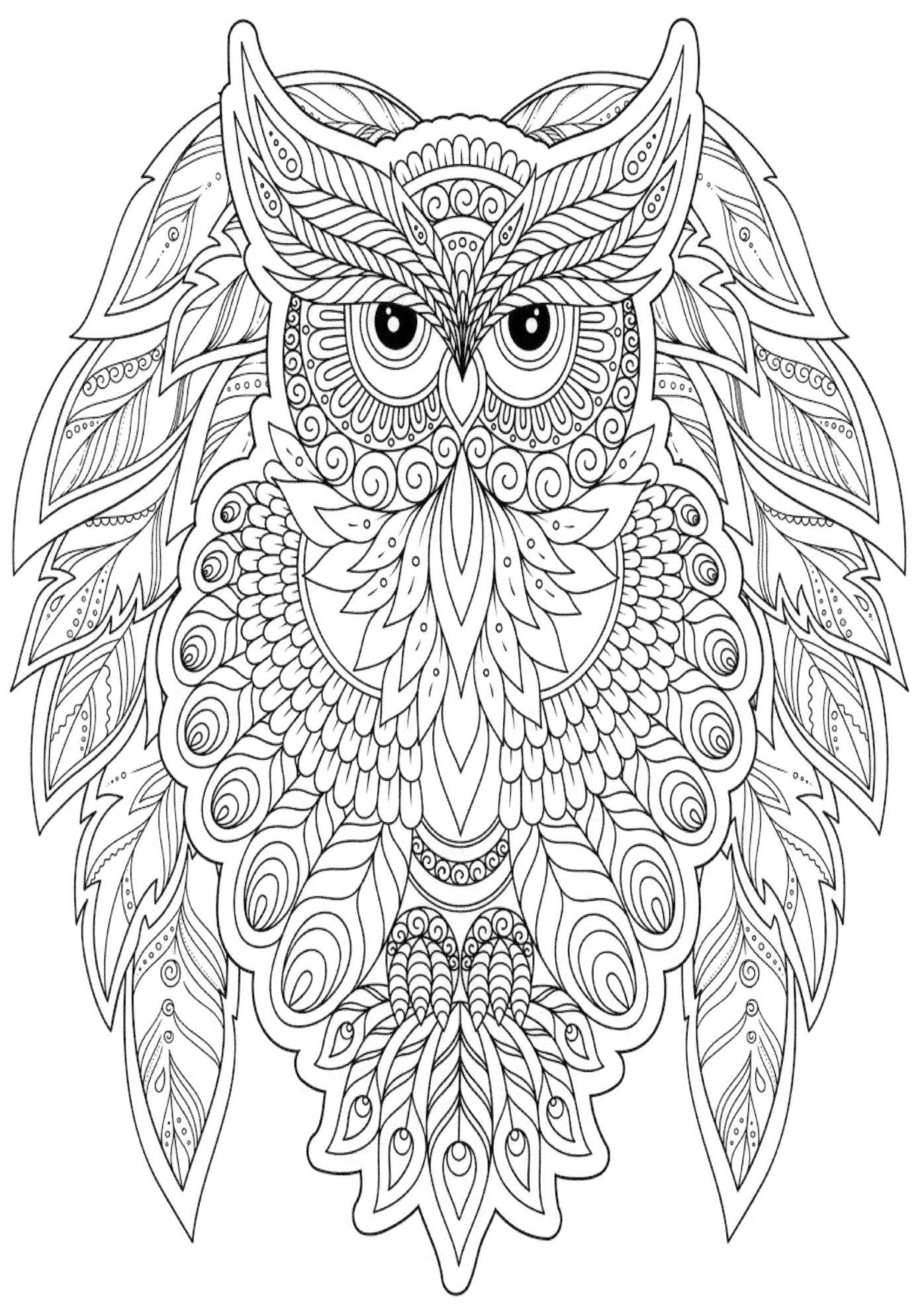

Coloring Test Page

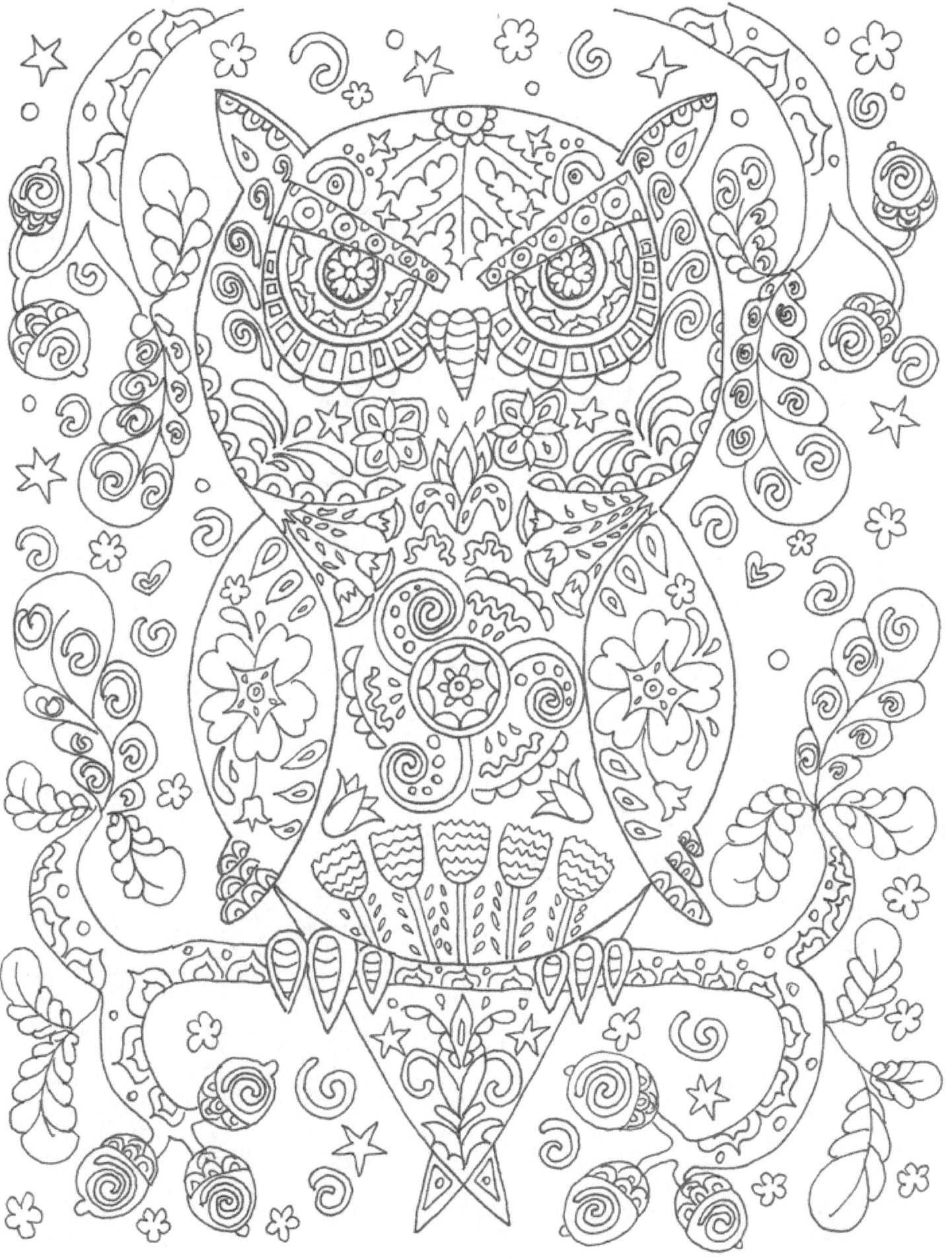

Coloring Test Page

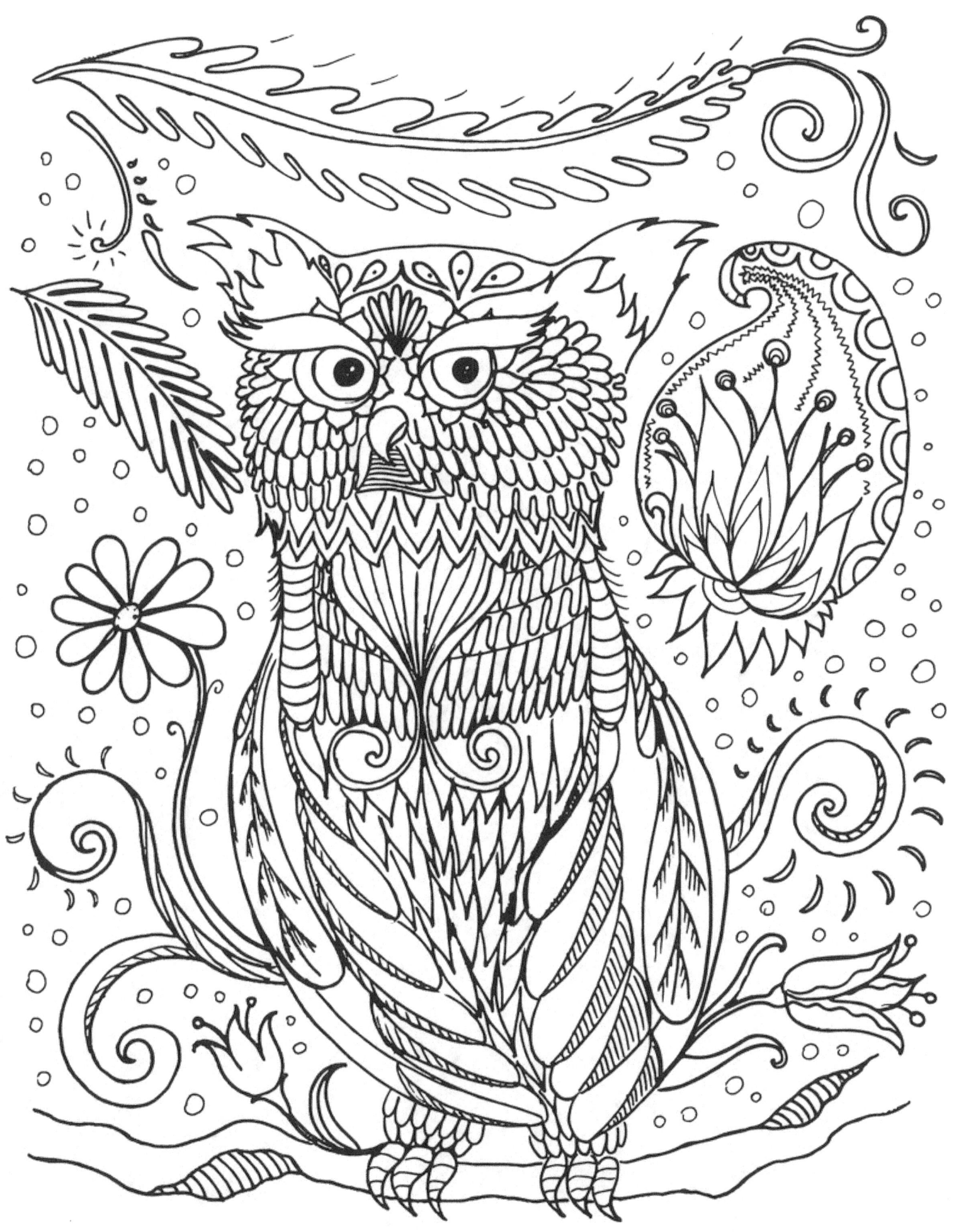

Coloring Test Page

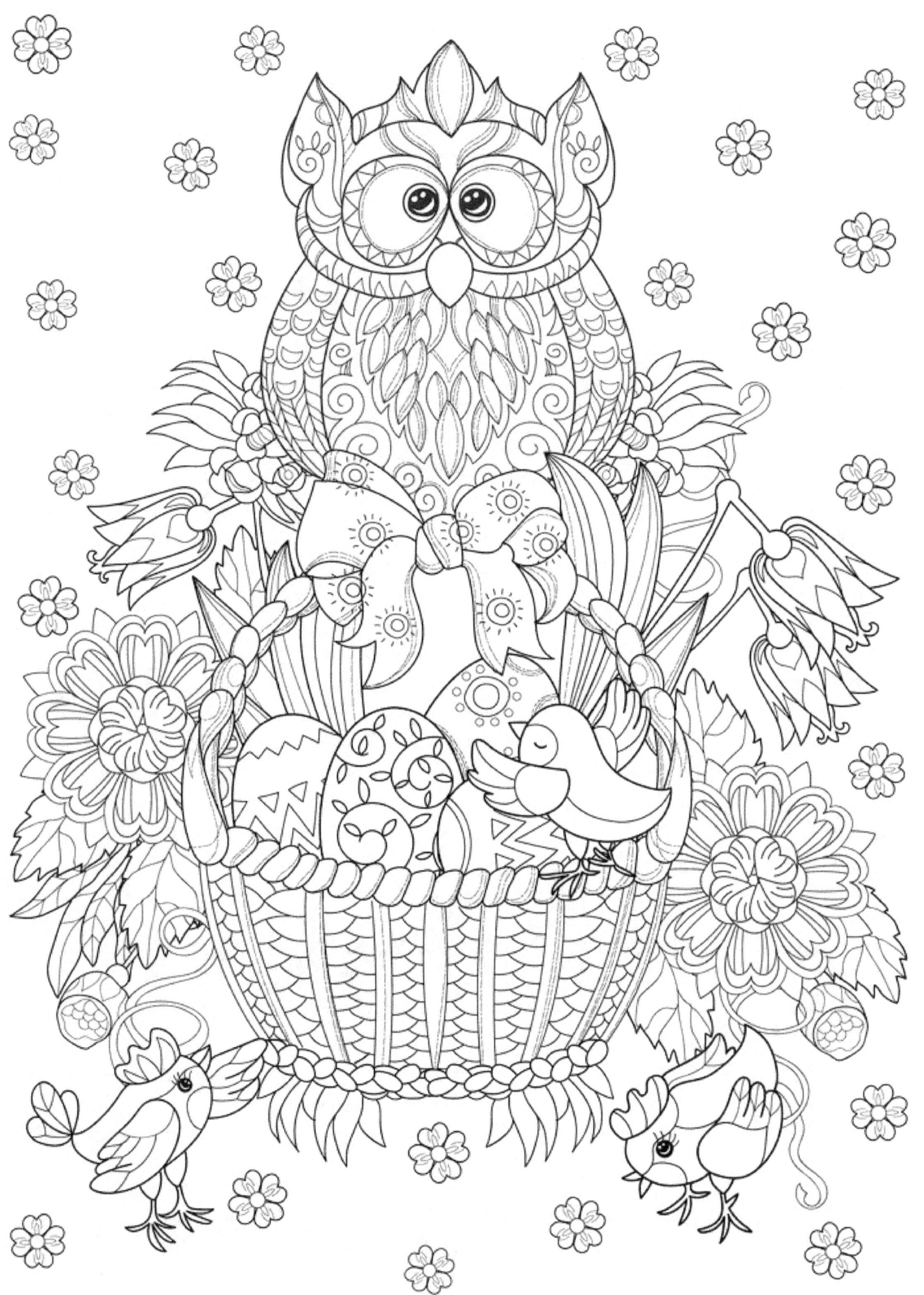

Coloring Test Page

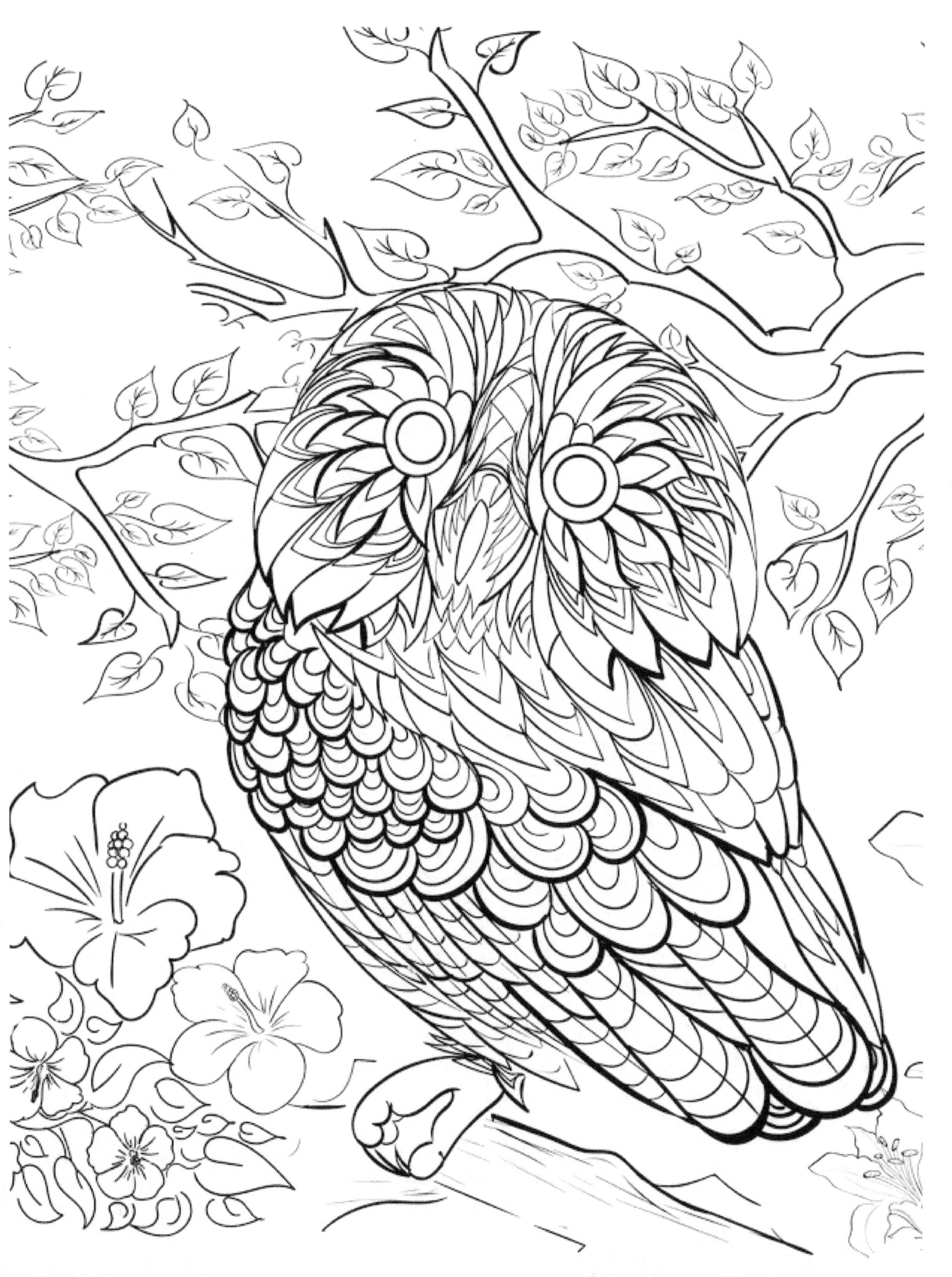

www.ingramcontent.com/pod-product-compliance
Lightning Source LLC
Chambersburg PA
CBHW080942170526
45158CB00008B/2351